white on white

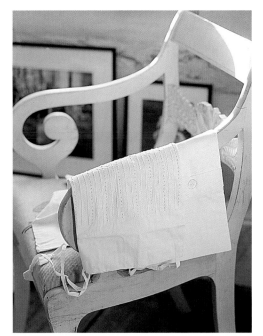

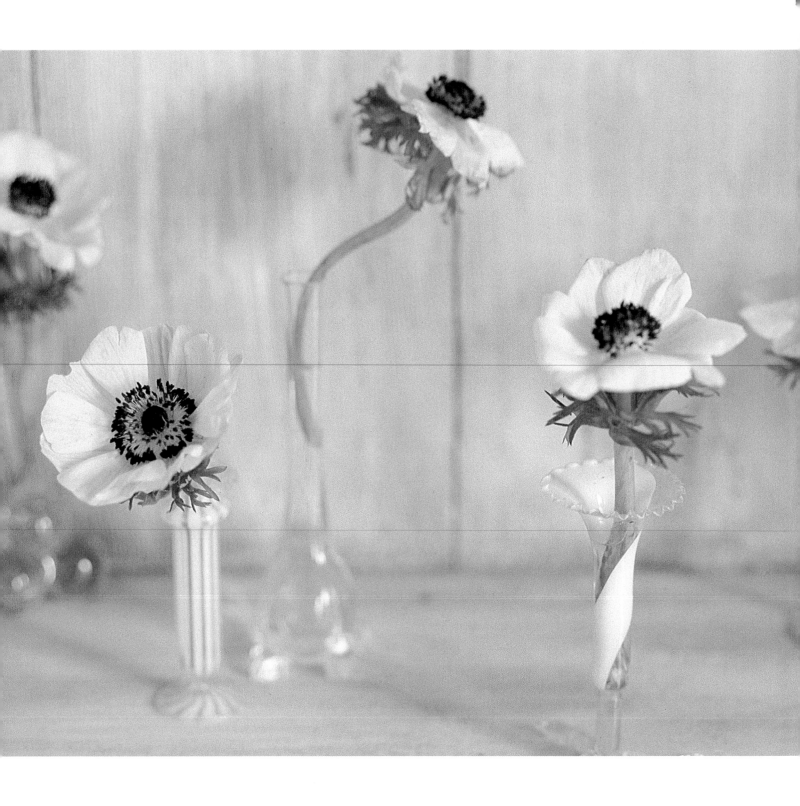

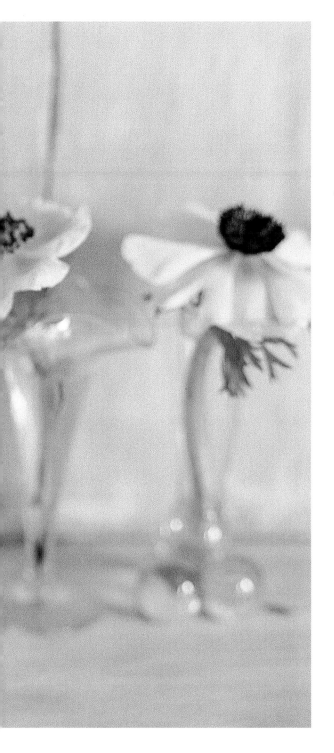

creating elegant
rooms with classic whites

white on
white

by **stephanie hoppen**

photography by **andrew wood**

BULFINCH

Dedication

To my fine wonderful granddaughters who bring sunshine into my life:

Natasha, Daisy, Mimi, Ella and Plum

First North American Edition

ISBN 0-8212-2666-5

Library of Congress Catalog Card Number 99-69431

Designed by Jeffrey O'Rourke

Text by Alex Parsons

Edited by Alison Wormleighton

Additional styling by Liz Bauwens and Rose Hammick

Bulfinch Press is an imprint of and trademark of
Little, Brown and Company (Inc.)

Printed in Singapore

contents

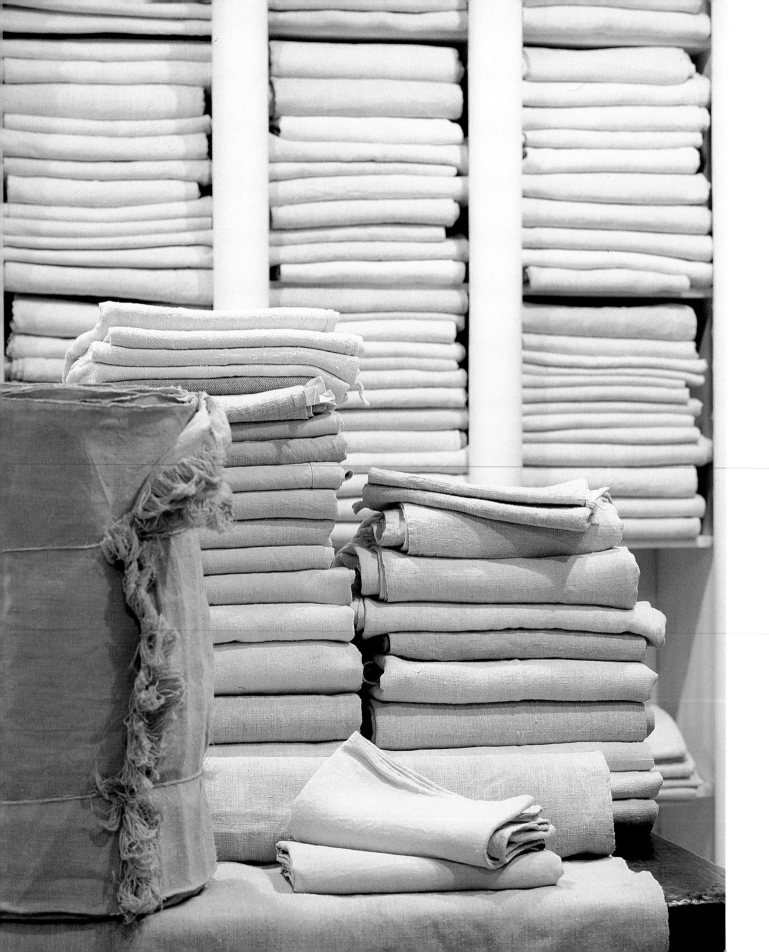

w h y white?

I am sitting at my computer looking out over the gardens at the back of Walton Street, London, and trying to recall what started my love affair with white. Why do I love to live with shades of white? What exactly is it about the palette that I feel so comfortable with? My walls are all white and cream, my bedroom is white, my sheets and flowers are always white. As a picture seller, I suppose white and cream make sense as paintings look best on monochromatic walls, and as I stock a great variety, from delicate drawings and watercolours through to importantly gilt-framed oils, I know I rely on a white background to make them sing out.

But, although that may have been the starting point, it's not the only reason. I love white because it is timelessly classic and stylish. It never goes in and out of fashion, it just is. The decision to go with white frees you from following decorating trends which is an enormous relief because you can blend ancient and modern together and create a wonderful harmony and a space that invites in light, tranquillity and space.

As we all know, white isn't just white. Ralph Lauren sells, I think, something like thirty-two shades of white paint, so there are plenty of hues on offer from rich, warm shades of clotted cream to the thin pale greys and blues of bird's eggs. And putting together whites that complement each other requires thought and care. My own drawing room is decorated with five shades of white paint, and I agonized over every one.

In this book you are going to see how important texture is in the monochrome interior. Without it you merely have a blank space with no life or vigour. Trying out various textures gives you great scope for adding interest and changing focus.

The essence of my personal style is to create an hospitable feeling in every interior, and I believe in abundance. Not just one bunch of snowdrops but a mass of them, not just one meringue perched on a plate but a massive bowlful. And that's the part of my style that this book is about: bounty, abundance and generosity which look very stylish in white.

I have organized this book seasonally, and this is because I really feel that the white interior is for all seasons. This book is a photographic impression of a year: from the delicate young whites of spring to the glitter and glow of winter. I hope you enjoy it.

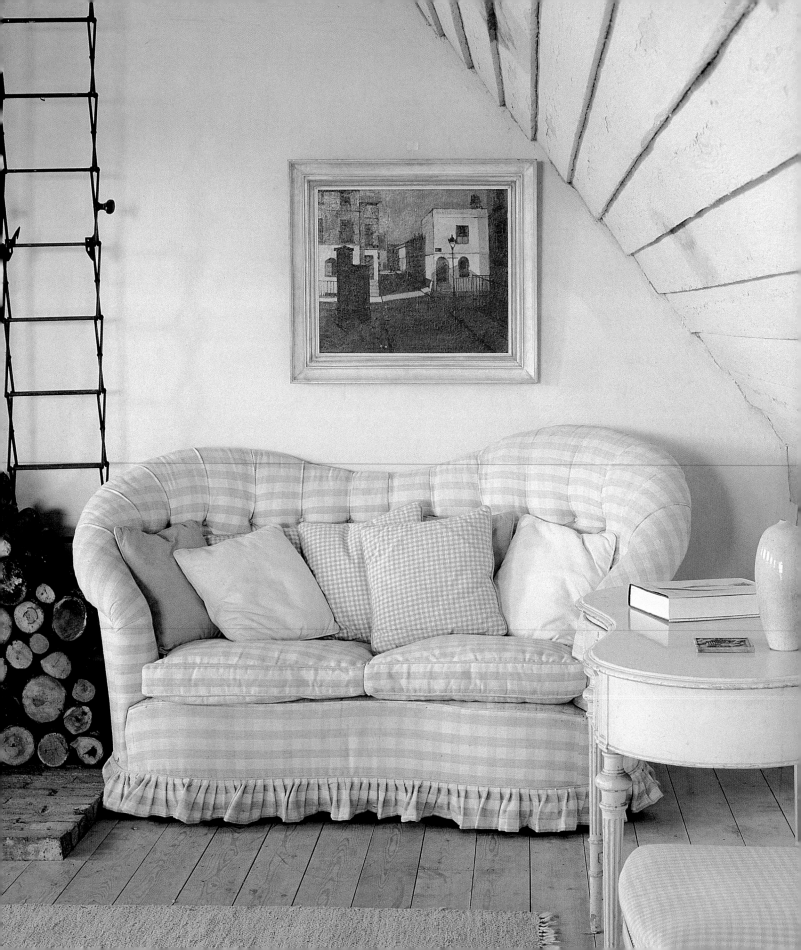

Spring

Fragile whites, like eggshells and tissue paper, are the essence of spring: whites with the translucence of icing drizzled onto a hot cross bun and the clarity and insubstantiality of a dewdrop. With its fresh breezes, spring means flapping white sheets on the clothesline and billowing muslin curtains at the windows. It is time to blow away all thoughts of snow and frost and set the scene for rejuvenation, shaking out the white linen and filling the house with spring flowers lit by shafts of sunlight.

Spring sees the appearance of early crocuses, white narcissi, apple blossom and creamy hyacinths. I like to use flowers in great swathes indoors, because I have always found a carpet of crocuses far more appealing than a lonely little bunch. Hyacinths, apart from smelling so evocatively of spring, are strikingly sculptural blooms. Mass-planted in geometric containers such as simple white painted square tins or lacquered Japanese boxes, they make a strong spring statement.

Not all seasonal decorations have to be floral, of course. Fill white bowls or baskets with white marble eggs, or chunky glass vases with white pebbles. Stones and pebbles can look smart and urban, while bleached driftwood and small shells will add a rustic touch.

I always feel that it's better not to overwhelm the senses with too much texture at this time of year. The contrast between thick, heavy linen upholstery and a fragile silk pillow is about as much drama as you want. White on white embroidered tablecloths or throws can look lovely. As far as I am concerned, bed linen should be crisp and white all year round but spring calls for an additional touch of celebratory decoration like an extravagant pile of antique embroidered lace pillows and a quilted throw with just a hint of colour.

The pale, pale green of tender shoots is the principal accent colour for spring: a green so young and new you can almost taste in it the freshness of the season. Then there's the hint of primrose yellow with its promise of Easter and daffodils. I'd also consider using a faint grey-blue — again, it's a tentative, newborn sort of colour that is perfectly matched to the fragile quality of the light.

white
magic

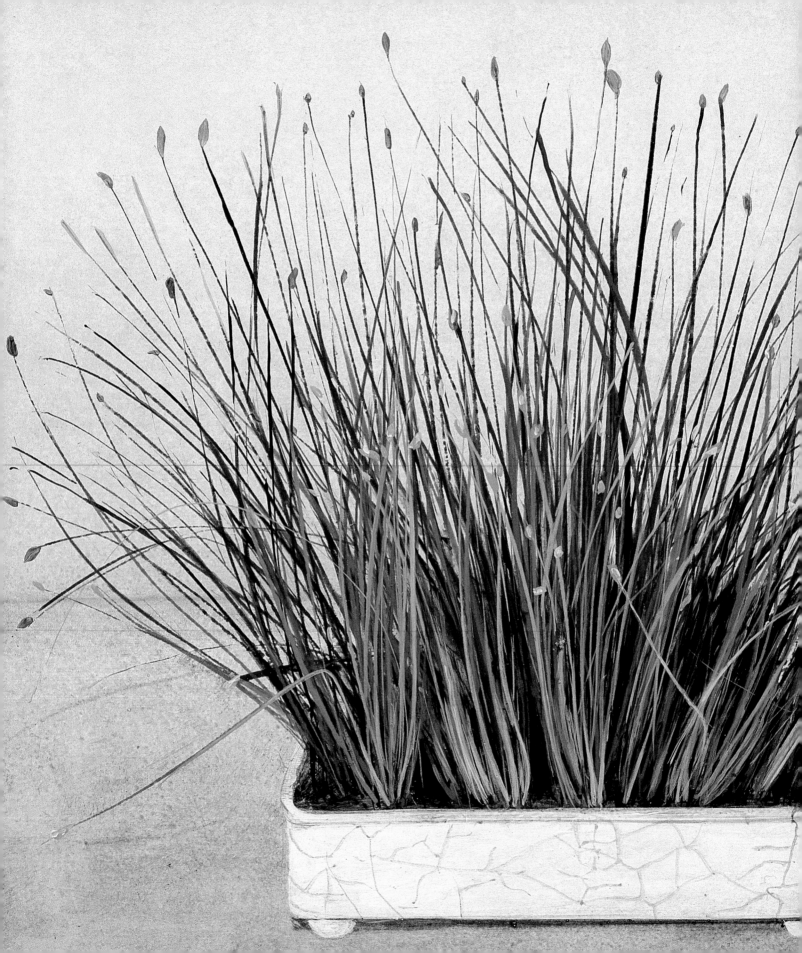

spring
essentials

This painting of bear grass in a white crackle-glaze trough, by the artist Galley, sums up spring for me. It is fresh and green and bursting with potential. I would use her paintings to brighten up corners where instinct would tell me to put a vase of flowers. These paintings have been specially commissioned by my gallery in London for use in this book. Galley is now painting all the white flowers I can think of in all the different containers I can imagine.

Small pictures don't necessarily need to be hung – they can be propped on shelves or on easels so they don't feel like permanent fixtures. Even large pictures can be leant against walls, like the ones in the inset photograph.

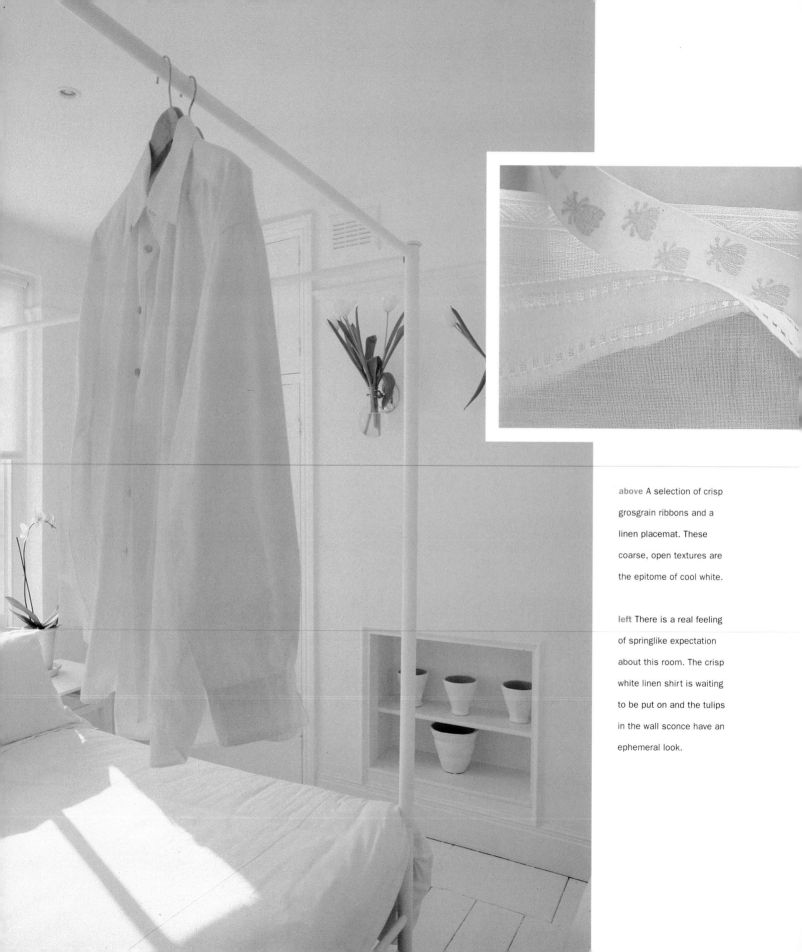

above A selection of crisp grosgrain ribbons and a linen placemat. These coarse, open textures are the epitome of cool white.

left There is a real feeling of springlike expectation about this room. The crisp white linen shirt is waiting to be put on and the tulips in the wall sconce have an ephemeral look.

right When it's not white, it's glass. These two beautiful champagne flutes are not merely drinking vessels, but objects of art. Another art form I really like is black and white photography. A framed monochrome print looks so good in a white interior.

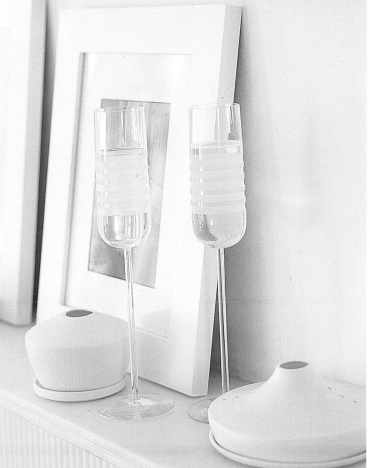

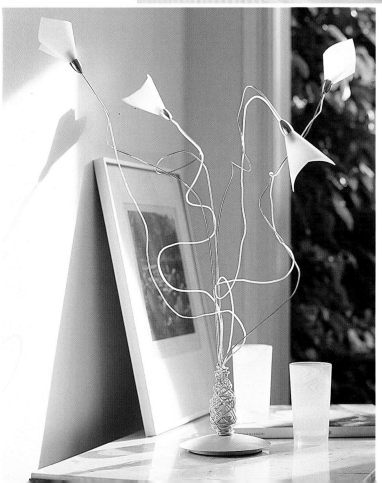

left A crazy, beautiful, plantlike light with paper shades and twisted plastic cords. The garden view beyond provides the perfect background, while the opaque glass tumblers add to the composition.

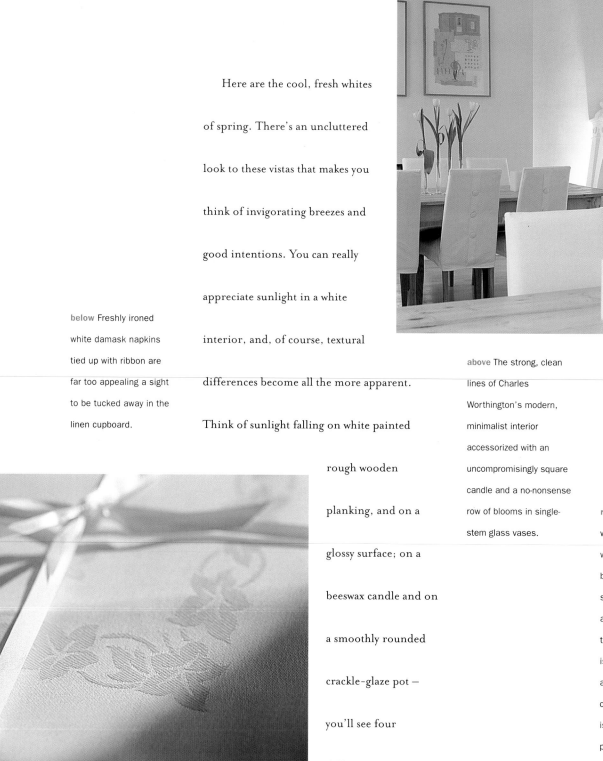

Here are the cool, fresh whites of spring. There's an uncluttered look to these vistas that makes you think of invigorating breezes and good intentions. You can really appreciate sunlight in a white interior, and, of course, textural differences become all the more apparent. Think of sunlight falling on white painted rough wooden planking, and on a glossy surface; on a beeswax candle and on a smoothly rounded crackle-glaze pot — you'll see four different whites.

below Freshly ironed white damask napkins tied up with ribbon are far too appealing a sight to be tucked away in the linen cupboard.

above The strong, clean lines of Charles Worthington's modern, minimalist interior accessorized with an uncompromisingly square candle and a no-nonsense row of blooms in single-stem glass vases.

right White painted wooden planking on the walls makes an informal backdrop to a pretty little side table with turned legs and a curvy top. The great thing about white on white is the way it unifies styles and periods. The side chair, which, like the table, is of antique Scandinavian painted pine, is upholstered in an Indian cotton check.

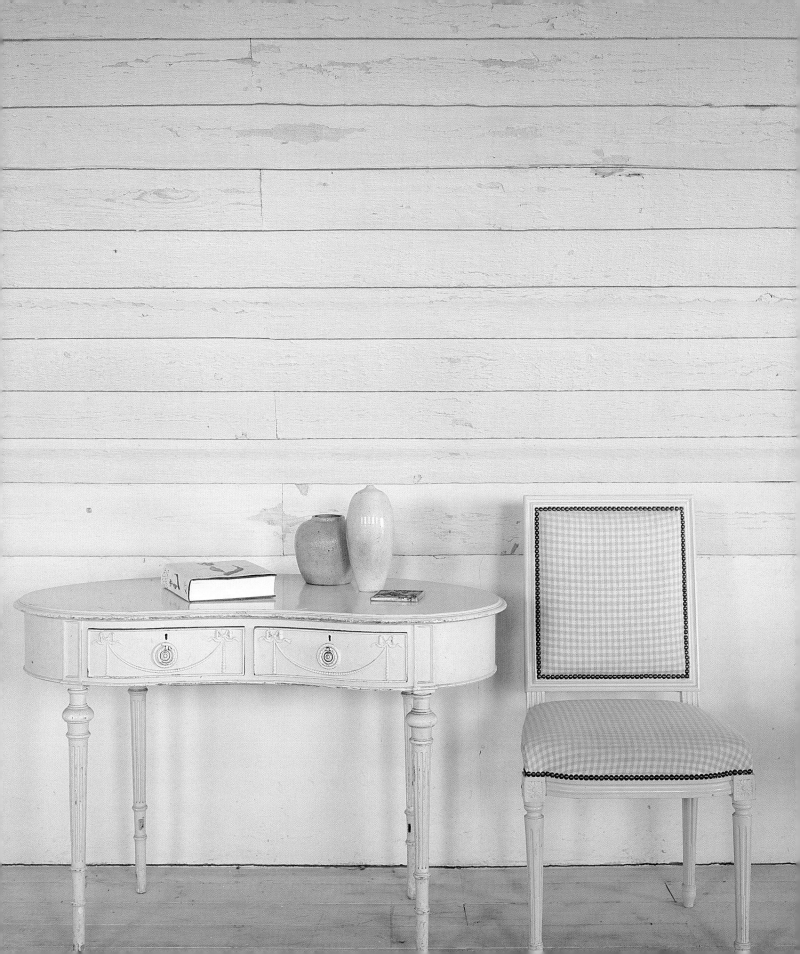

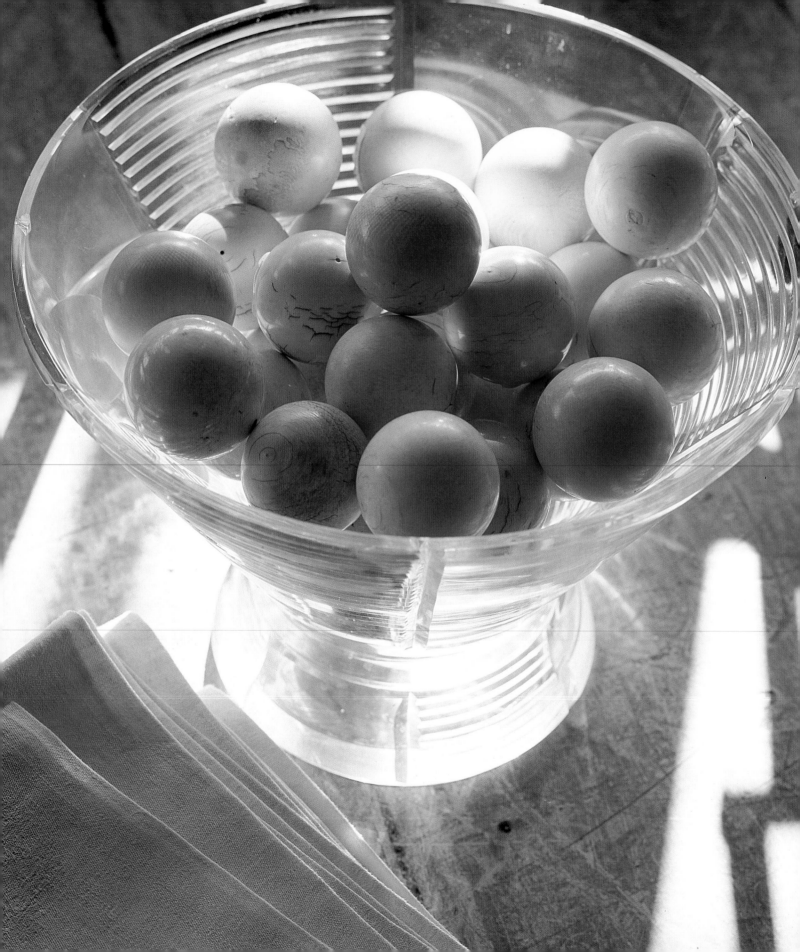

easter celebrations

Easter, of course, is all about eggs, and there are few objects more universal in their symbolism than the egg. Its sculptural shape, for one thing, could hardly be bettered by Michelangelo, and its mysterious promise of things to come is embedded in ancient folklore as well as modern science-fiction. The colour of eggs ranges from speckled brown to a white so delicate it is almost blue. The texture varies, too: most birds' eggs have a slightly matte texture, some more so than others — but not all eggs are laid by birds. Decorative eggs are manufactured out of smooth, shiny marble; hacked out of granite and then polished; or formed out of plaster or porcelain and then painted. There is also the question of scale.

Unadorned ostrich eggs make strong decorative pieces, and little nests of quails' eggs are as good to look at as they are to eat.

We tend to think of Easter in terms of yellow daffodils and baby chicks along with dark brown chocolate confectionery. But if you take as your themes the eggshell and the pale green shoots of spring, you can create a fresh and different ambience for your Easter celebrations.

The theme of my Easter table is an Easter egg hunt. Not having a garden to hide the eggs in, we made a landscape on the dining table instead. We created little grassy knolls in white bowls with pretty scalloped edges, and in silver baskets of varying heights. Then I gathered

Eggs? No. This is a prized collection of antique ivory billiard balls piled into a stylish 1920s Baccarat bowl. Egg shapes in glass look wonderful – light glints off the glass and defines every curve.

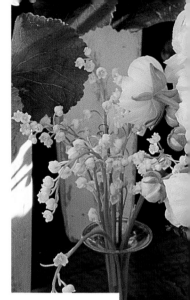

together every small, low vase I could find and

filled them with spring flowers.

I particularly liked the little pressed-metal

planter in the shape of a small box, made from

a strip of metal cornice of the kind used in

turn-of-the-century American and Australian

houses. These readymade cornices date from

the days when the effects of elaborate

plasterwork were much desired, but both the

craftsmen and the pattern books were scarce.

Scattered about the table are peeled quails'

eggs, white shortbread and white-chocolate

Easter eggs. All the actual eggs, which are duck

eggs that have been hard-boiled to avoid

accidents, were left in their natural white state.

I certainly didn't feel the need either to dye or

to paint them.

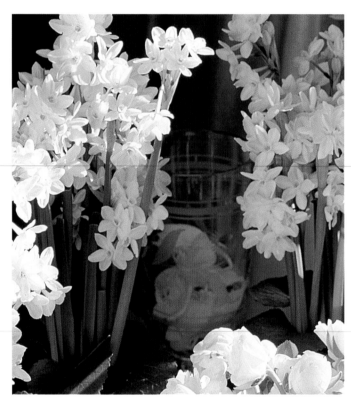

above A mini forest of
"Paper White" narcissi on
my Easter table. The
person who collected the
most eggs in sixty seconds
won a white-chocolate
Easter bunny.

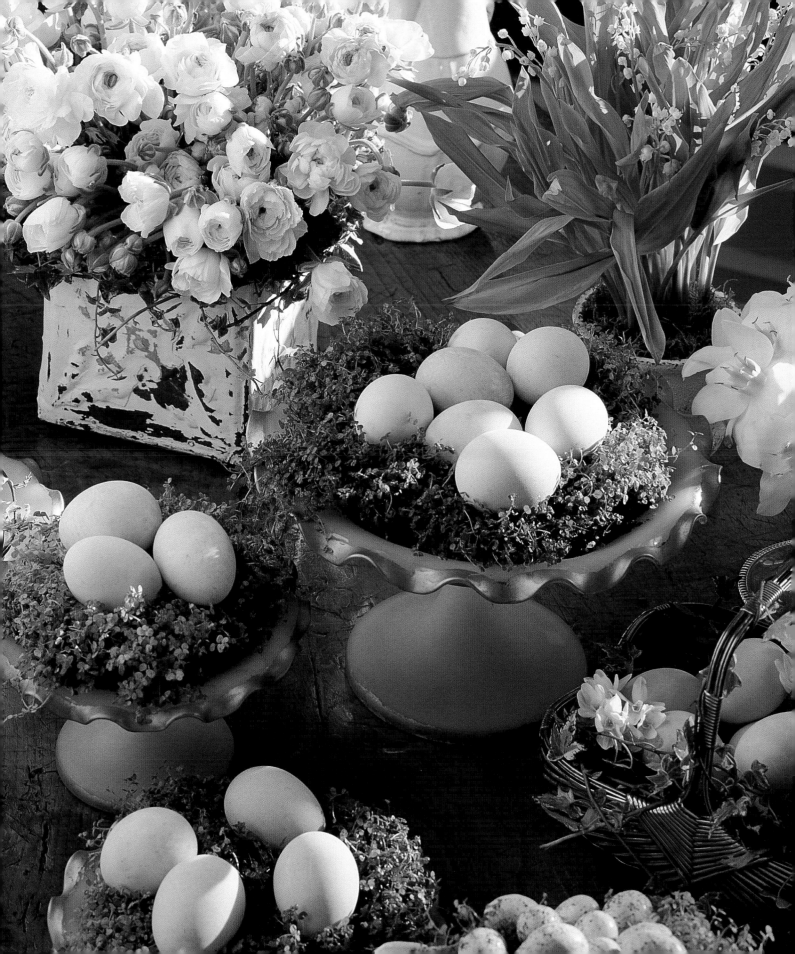

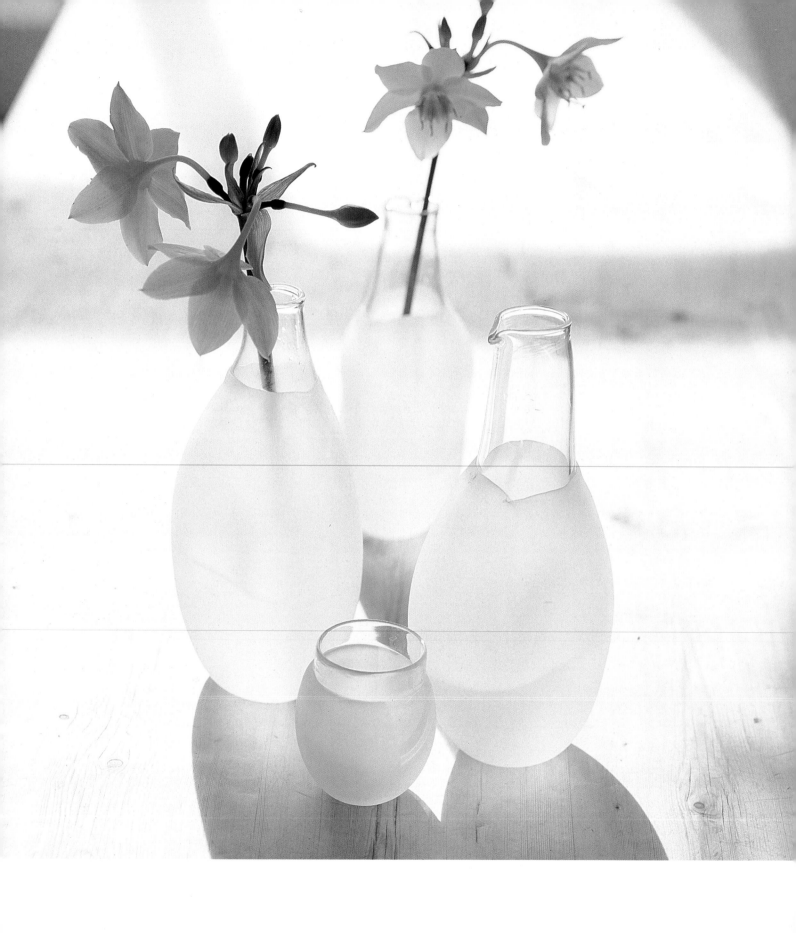

spring
flowers

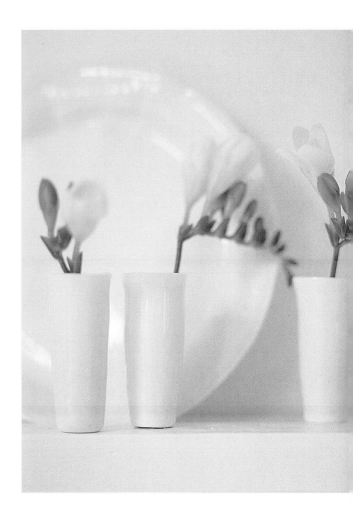

The white or near-white spectrum is truly

enormous, taking in such colours as ivory,

sand, stone, cream, buttermilk, fromage,

mushroom, and ecru, as well as many tones of

white, and nowhere is this better demonstrated

than in the world of flowers.

The range of white flowers is staggering —

from the first snowdrops to the last Christmas

rose, from the tiny gypsophila to the large

Easter lily, and from the simple daisy to the

exotic orchid.

I find that white flowers are infinitely

versatile; and without strong colours to distract

the eye, the varied forms and textures of

flowers and foliage stand out all the more.

left I'm not much of an advocate of the less-is-more theory when it comes to flowers, but in the case of these charming little vases I'm prepared to concede that single blooms in a well-chosen container can look great. In the main picture, delicate orchids grace a group of shapely frosted glass beakers.

right above Buttery-cream freesias in milky white china, a wonderful combination.

right below This unusual orchid adds a certain something to the relationship between a curvy vase and a beautiful dish.

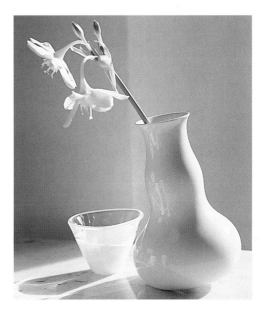

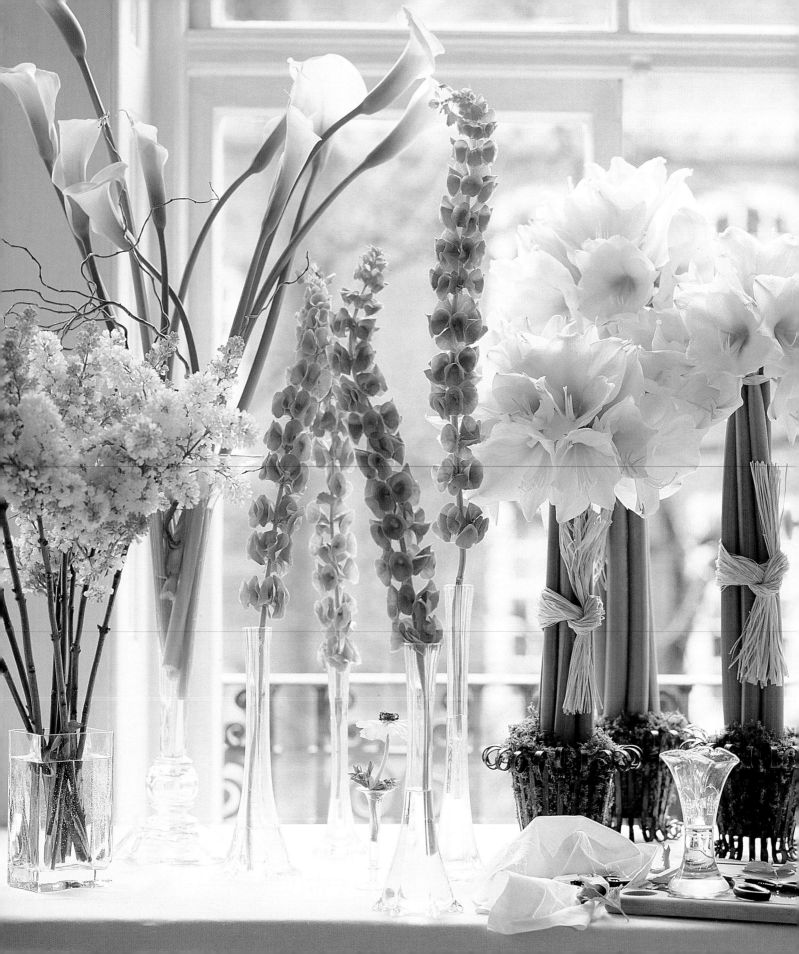

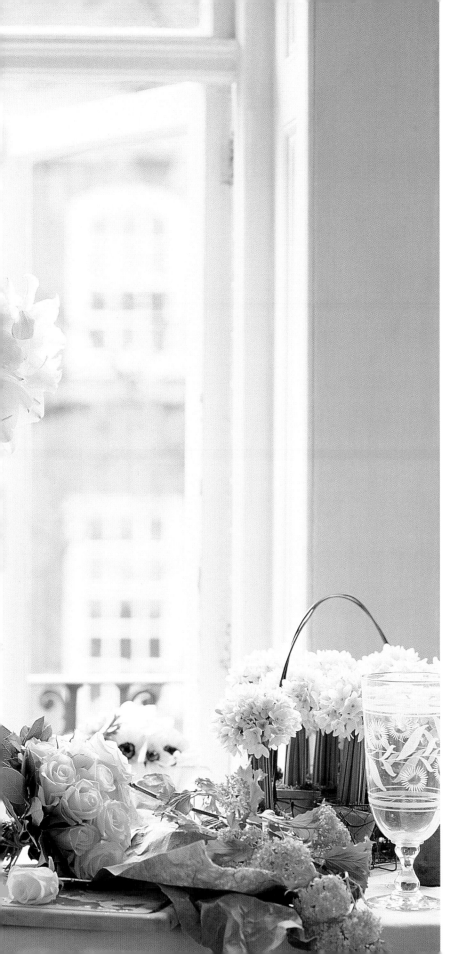

wedding flowers

The occasion here was a spring wedding breakfast. It is quite a challenge to fill an apartment with white flowers, and white flowers only, but the effect was ethereal, magical, and very romantic. To make up for the lack of variety of colour, Dave Lawrence from the London florists Grovers went for shape, texture, and association. Arum lilies gave the most sinuous, sculptural, "urban" shape, while white lilac added a wonderful scent. Sensuous, abundant blooms of amaryllis were clustered together in containers filled with compost and moss, and then tied up with raffia. White country roses were chosen for romance, and white anemones for their delicacy.

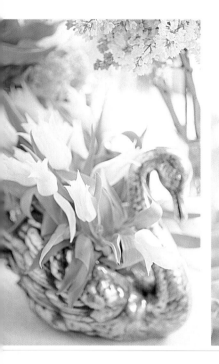

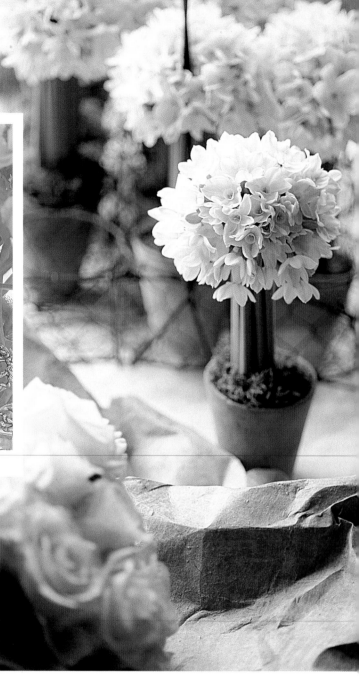

previous page For a spring
wedding in London, all the
flowers are on the kitchen
table ready to be arranged
throughout the apartment.
White arum lilies, white
country roses, white lilac,
white amaryllis, white
anemones... there is no
other colour, apart from
green. Nothing could be
more springlike or more
perfect for a wedding
reception at home.

above left and centre
Little posies adorn the
tables, some in silver
swans and some in glass
with silver decoration.
Shells scattered on the
tables add a pearly sheen.

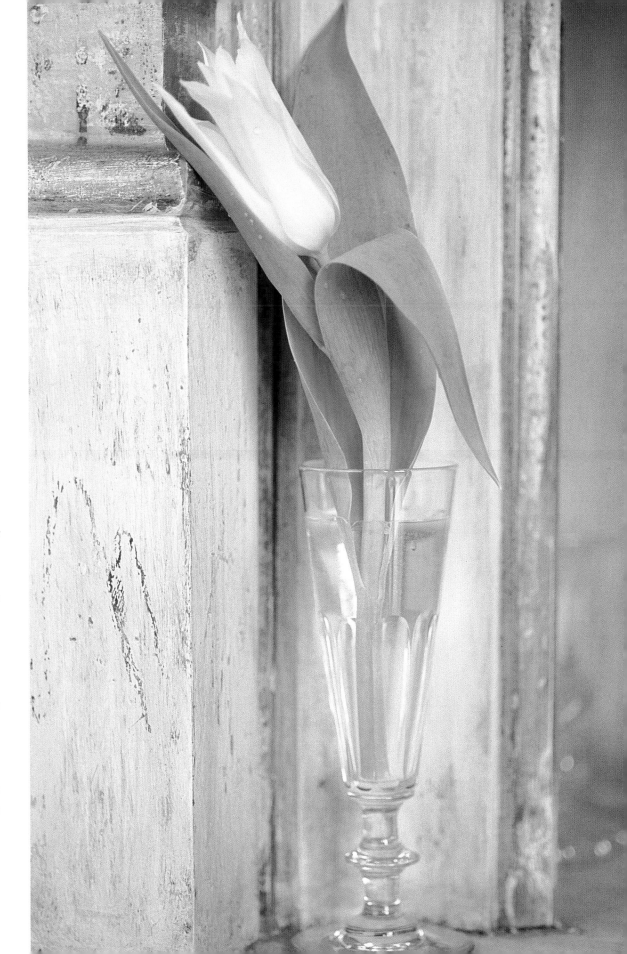

left Miniature "Paper White" narcissi tied with raffia and stuffed into clay pots make simple, inexpensive yet delightful centrepieces to scatter on all the tables for the wedding reception.

right The creamy white petals of a single tulip are set off by the mellow, time-worn surface of a venerable bookcase, demonstrating once again that shades of white need never be bland or uninteresting.

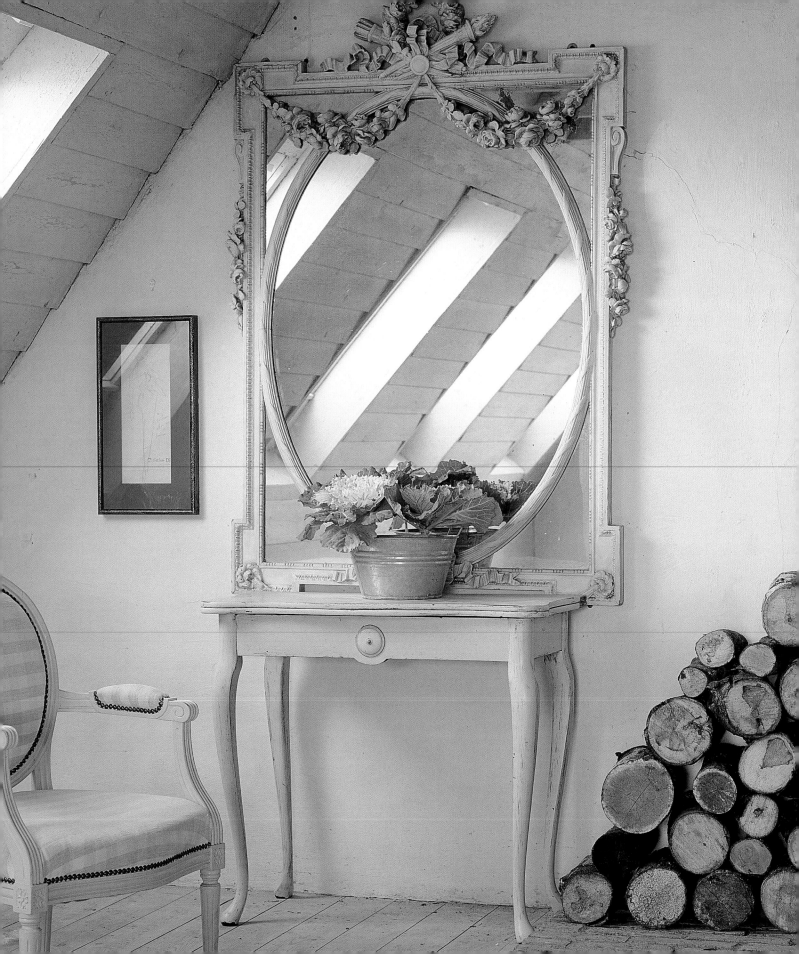

spring
interiors

The white on white interior adapts well to a change of season, because it picks up on the quality of light, instantly taking on a seasonal hue. Accessorizing the white interior for spring means a subtle shift in soft furnishings, and a rethink on the flowers and lighting. That way you can clear the decks ready for spring.

This unusual Suffolk barn was built in the 1960s and converted by the present owner, Jorn Langberg. It is used as an exhibition space for contemporary British artists during the autumn. In spring and summer it becomes an additional living space to the small sitting room in the main, seventeenth-century house. Flooded with light from all sides, the room occupies the whole upstairs floor, and enjoys beautiful views of the Suffolk countryside.

One of the outstanding features of this room is the collection of white-painted Gustavian furniture, made during the reign of Sweden's King Gustav III, during the last quarter of the eighteenth century. Scandinavia, like the rest of Europe, was much influenced by French style at this time. The Scandinavians, however, didn't have the fine walnuts and mahoganies used by the French , so the designs were made up in pine. To protect the porous grain, they were painted with the pale, muted paints so strongly associated with this period — cool, dusky blue, pearl grey, straw yellow, and, as here, off-white.

left The beautiful carved wooden mirror on the end wall of the barn is French, and dates from about 1800. It was painted white originally. The pretty console table under the mirror is Gustavian – antique Scandinavian painted pine.

The old house and the new barn are unified by their shades of white. The effect on the walls and beams was achieved by first painting the walls a pale, pastel grey and leaving the exposed beams in their original shade of brown. Then, just one coat of lime-based paint was sponged on over the walls and beams, so that the surfaces retained their individual characters but were unified in tone. The pine floorboards were washed with a Finnish lime- and water-based paint mix that gave the boards a bone-white colour.

The photograph on this page was taken in the main house. The seat cushion of the Gustavian chair was embroidered in petit point by the owner's mother. The occasional table is a typical Gustavian piece.

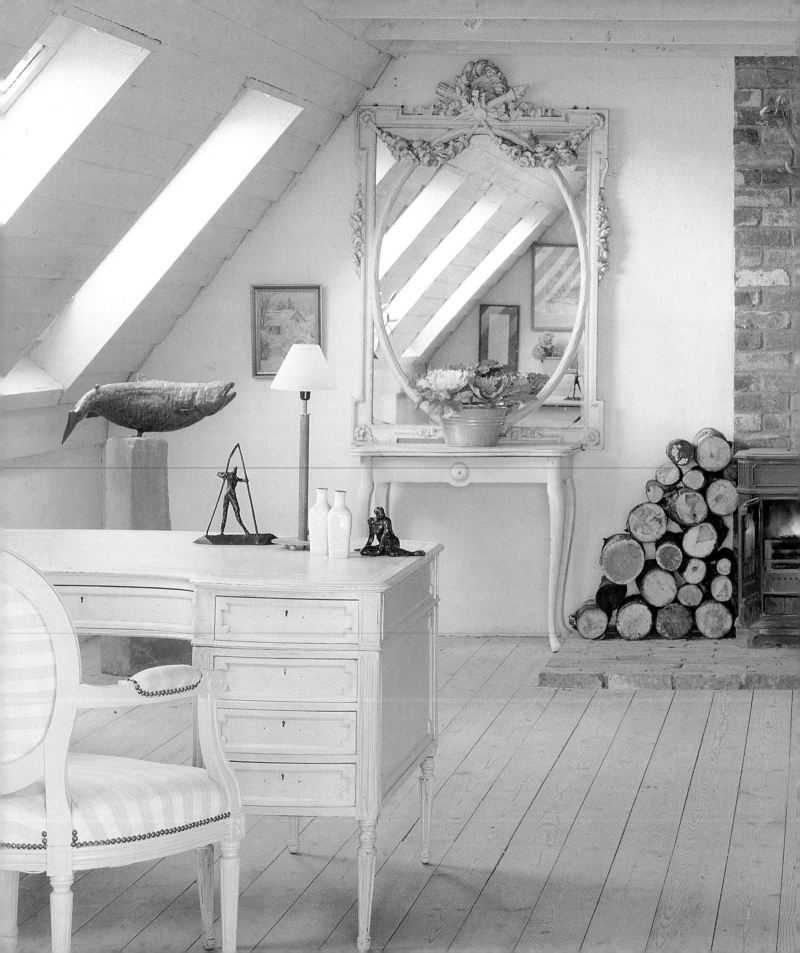

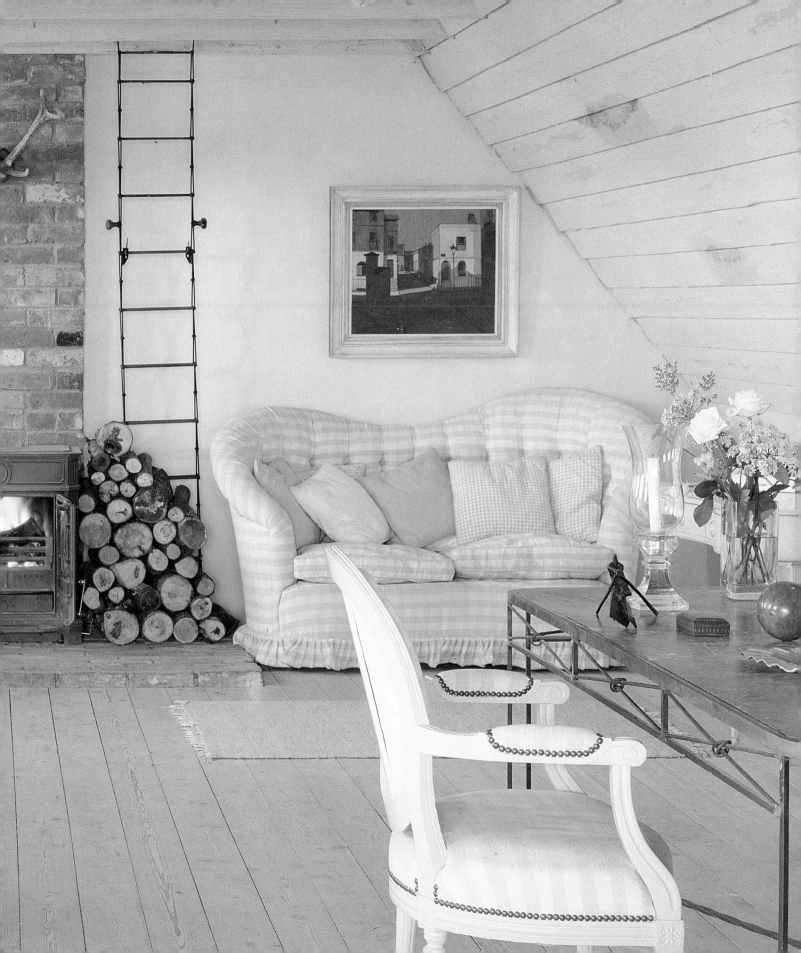

antique whites

previous page A view of
the barn. The steel and
zinc table on the right is
made by a modern Danish
craftsman, Tage Andersen.
The magnificent salmon
sculpture and the smaller
bronzes are by the British
sculptor Lawrence
Edwards, and the
enigmatic metal ladder
going nowhere is an
installation by the owner.

The bedroom and bathroom
are in the roof space of the
old main house. The bath
itself is situated so that the
bather gets a view of Suffolk,
but Suffolk gets no view of the bather.
The bath is encased in painted pine,

and the poles, far

from being an

ornamental device,

are strategically

placed to steady the

bather's passage up

the step and into

the tub.

above The accessories
are simple, natural forms
and the towels are
pristine white. The pale
pearly greys of the walls
lend a springlike feeling
to this light-filled space.

right The bathroom
cupboard, an early
nineteenth-century
perfumier's cabinet, is
appropriately filled with a
sparkling collection of
antique perfume bottles
and natural soaps. There
are pictures everywhere
in this house, even leaning
against the bathroom
walls.

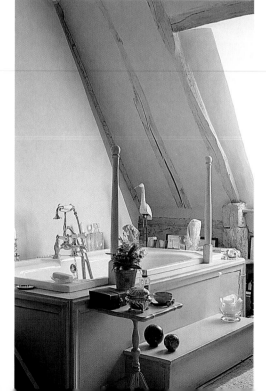

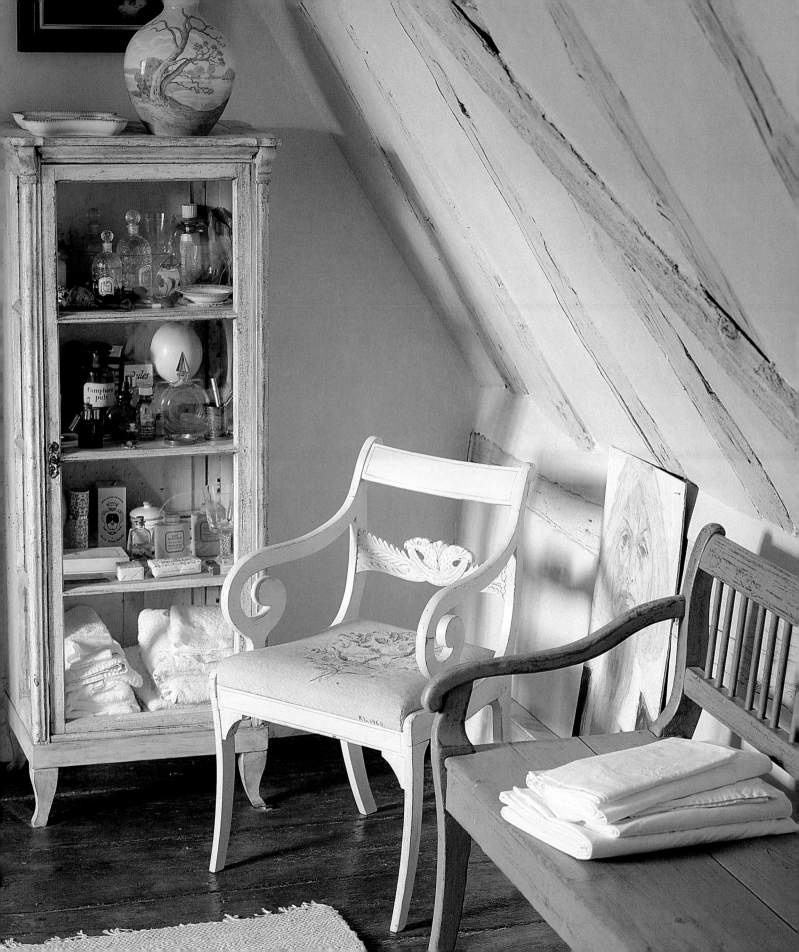

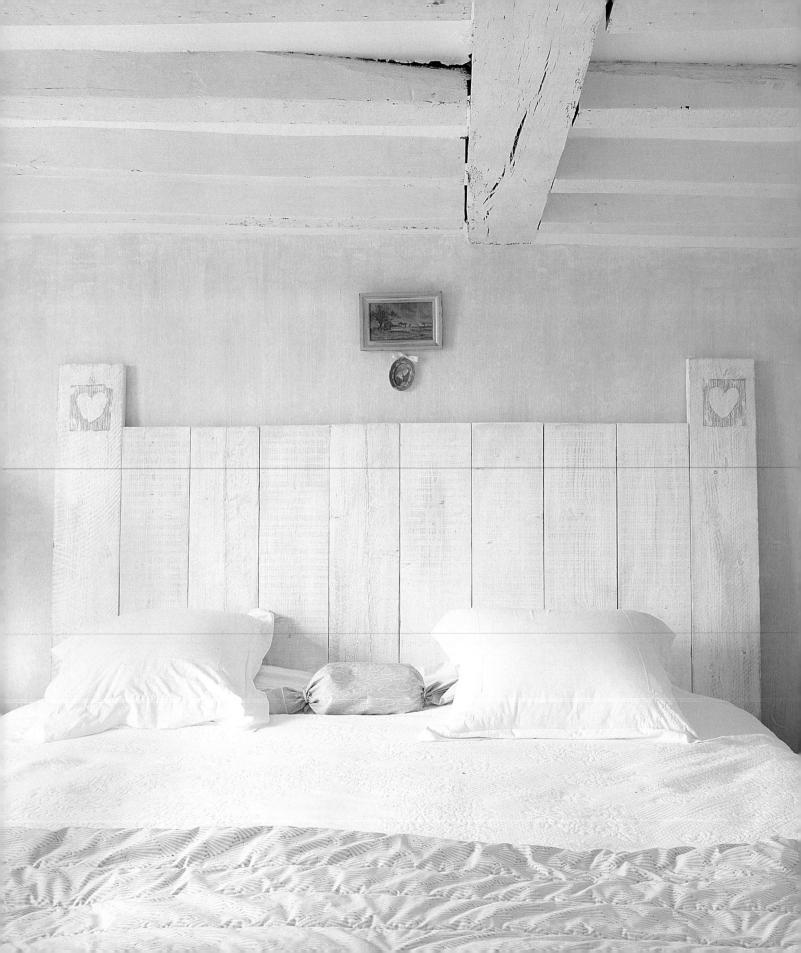

left A specially made 7-foot bed was sanded and painted by artist Arabella Johnsen to match the cool whiteness of the bedroom in her fifteenth-century farmhouse.

right A witty bathroom curtain made from fine cotton muslin with simple pockets sewn on the inside, just two of which contain starfish. I love light streaming through white – it makes the window opaque, but still allows it to do its job of letting in light. The little zinc buckets on the rim of the bath are a canny way to hide bathroom clutter.

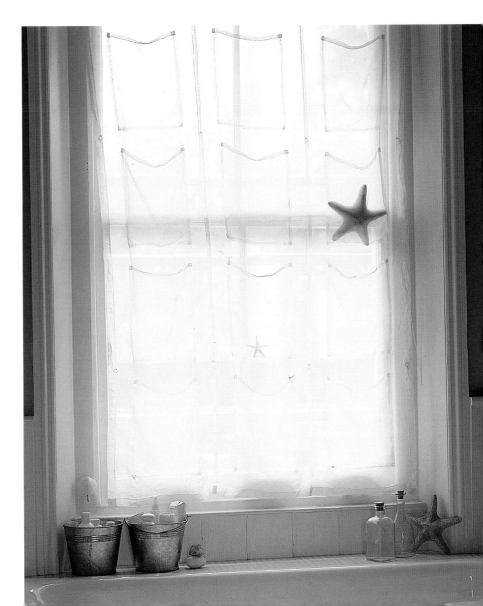

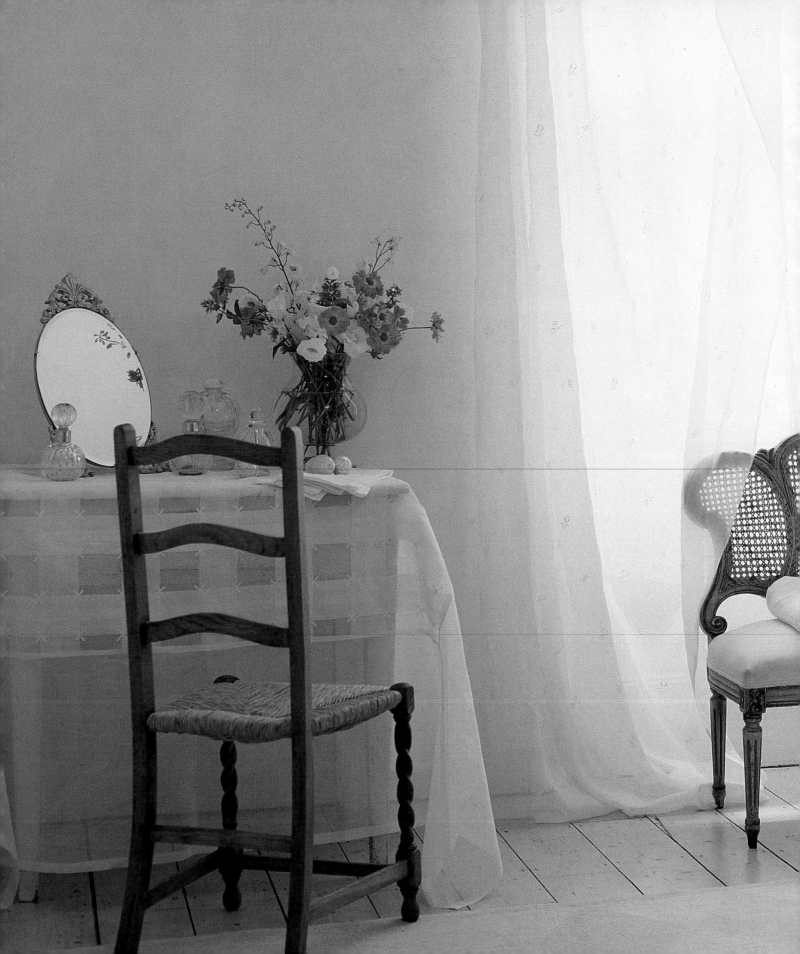

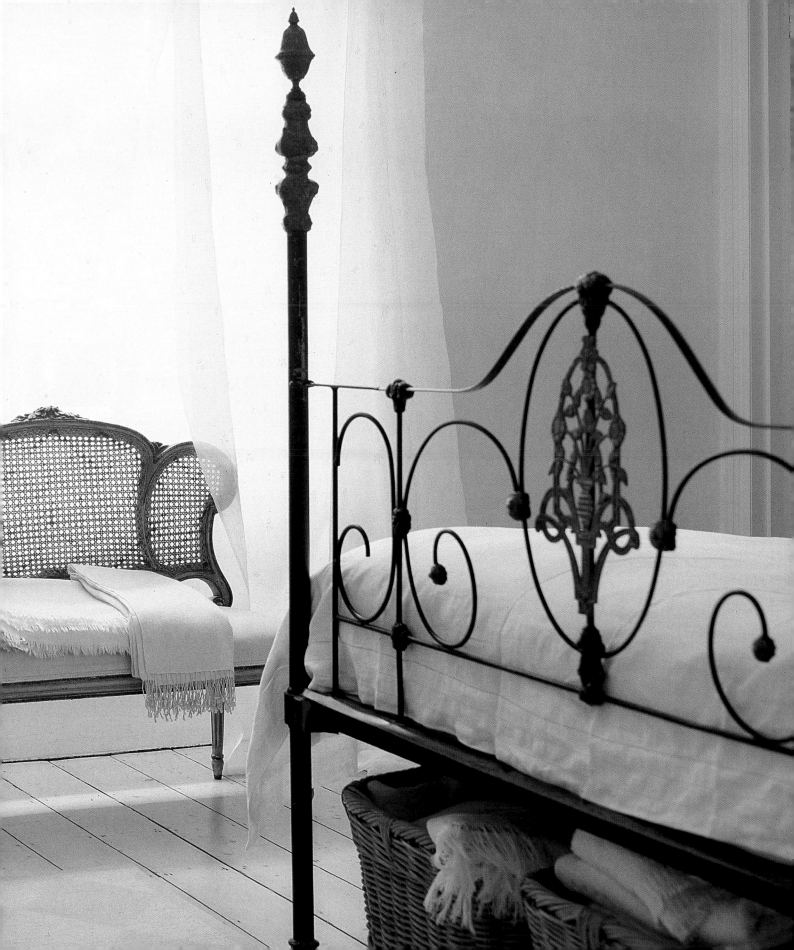

country
bedroom

Texture is king in the no-colour environment,
as proved by these details of the French country
bedroom featured on the previous two pages.

Even for the bare bones of a room, there
are a lot of decisions to be made about texture.
Do you want soft carpet, bare boards, shiny
stone, or smooth synthetics on the floor? Pale
wooden floors look smartly urban, while white
painted floorboards appear casual and rustic.
Sisal matting is nicely neutral and natural.
Marble floors, though cold underfoot and
expensive, look stunningly grand. Even paint
has an apparent texture. Gloss paints look
hard, matte paints soft — and lime washes are so
soft that they almost seem warm and yielding.

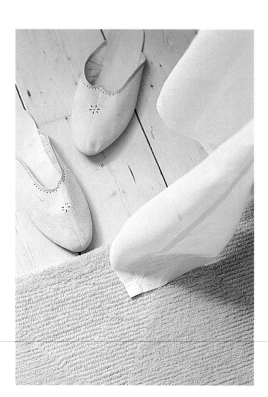

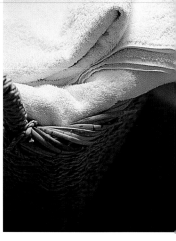

right Muslin curtains and a translucent cotton organdie cloth thrown over the dressing table lend an ethereal quality to the room – it's like decorating with pure light. The only colour comes from the flowers.

above A textured wool bedside rug softens the painted pine floorboards. Even the pale leather slippers and starched white cotton continue the texture story. There's no distracting colour, just a tactile feast.

previous pages A view of a French country bedroom showing the simple sprigged muslin curtains, the newly-upholstered bergère seat, the dressing table, and the iron bedstead. Linen is stored in large wicker baskets under the bed.

right Thick white towels are piled into a huge wicker storage basket. Sometimes household linens just demand to be let out of the cupboard.

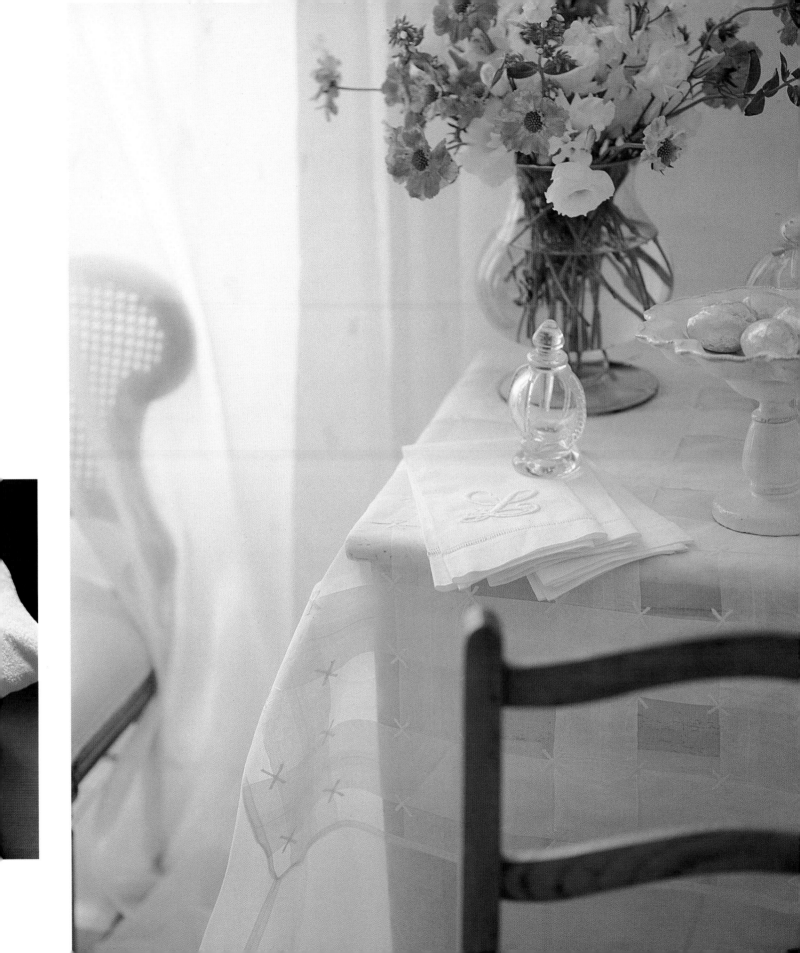

right Another painting by Galley. This one is of Helxine soleirolii (mind-your-own-business) planted in a white ceramic pot. All of the flower paintings in this series have white painted, textured frames.

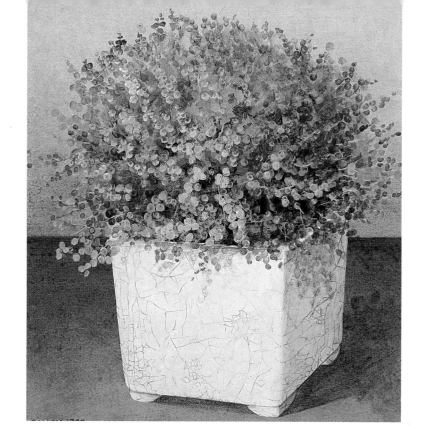

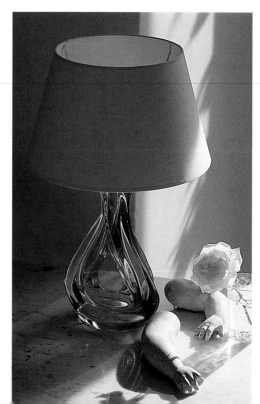

left A lovely twisted glass lamp base, the remnants of an antique china doll, and a single rose in a glass vase create a cool, slightly surrealistic still life on this marble table.

right The drawing room of international hairdresser Charles Worthington's London home reflects the colour scheme which he has chosen for the entire house. Every stick of furniture is upholstered in white fabric, any wood is pale and accessories are minimal.

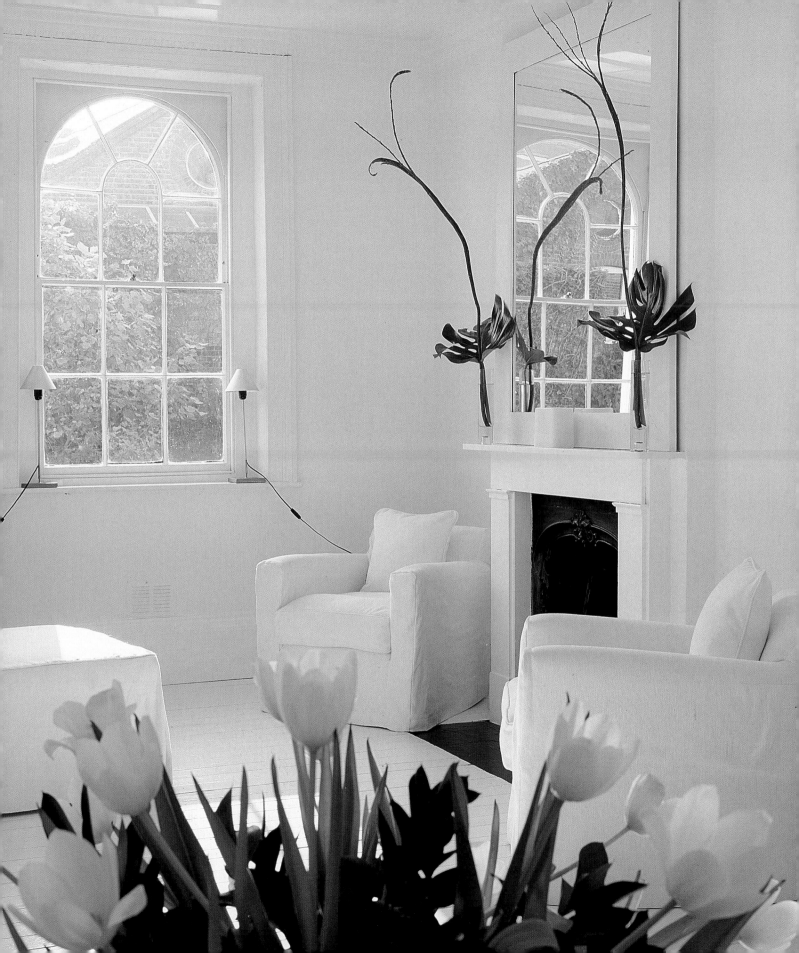

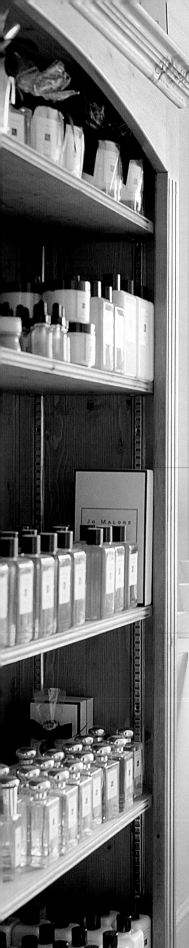

above The dramatic shapes and translucence of amaryllis blooms make them ideally suited to a white on white scheme.

left The London apartment featured here and opposite belongs to world-renowned perfumier Jo Malone. Tremendously calm and easy on the eye, it is a haven of tranquillity from the bustling metropolis outside. The smell in this room, I have to say, is quite delicious – as you would expect.

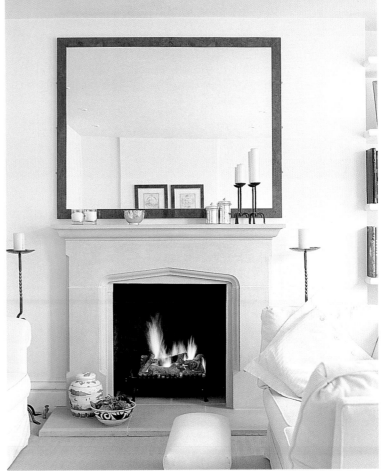

right In Jo's living room, the wooden frame, the cream marble fireplace, and the golden carpet add warmth to an otherwise pure white scheme. This apartment combines classic shapes and objects with a truly contemporary feel.

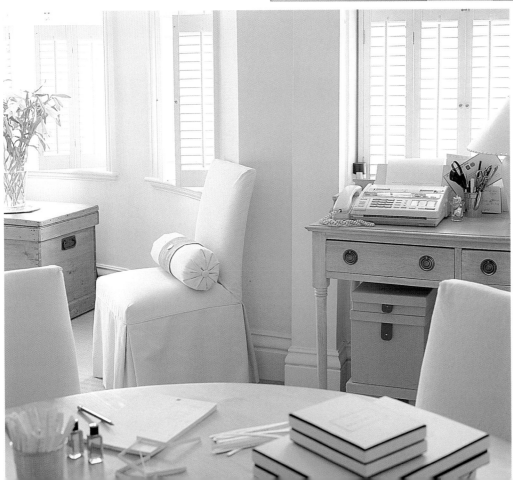

left Deliberately minimal, the palette of pure white is broken only occasionally, by natural wood. In this room, which doubles as a workspace for Jo, even the fax machine is white.

bathroom
spring tonic

My bathroom is a very special place to me. It probably has more framed drawings, photos of my grandchildren, and little objects I adore than any other area of the house. Yet, in spite of its clutter, it is both tranquil and calm.

The soft creams and whites that I have used throughout give the room its feeling of peace. The original antique French lace curtains, which can be seen in the photograph overleaf, were starting to disintegrate, so I decided to have them honourably retired to a safer, less sunny window.

When walking past the fabric shop Andrew Martin, in London's Walton Street, my eye was caught by some amazing fabric that was made from a banana plant and had strips of bamboo running through it. This became my bathroom shades — and so, overnight, my bathroom had to undergo a sea change, and acquire a Zen-like quality to match the shades. Paring down the accessories and adding some shoots of bamboo did the trick — the bathroom was transformed.

inset The walls are completely covered with lovely nineteenth-century French drawings, charcoals and sanguines (chalk drawings the colour of dried blood). I've had these framed in all sizes and shapes of gilt frames, and they blend perfectly with the new shades.

right My new springlike calm and uncluttered bathroom. The marble-topped vanity unit is home now to a restrained display of bamboo shoots.

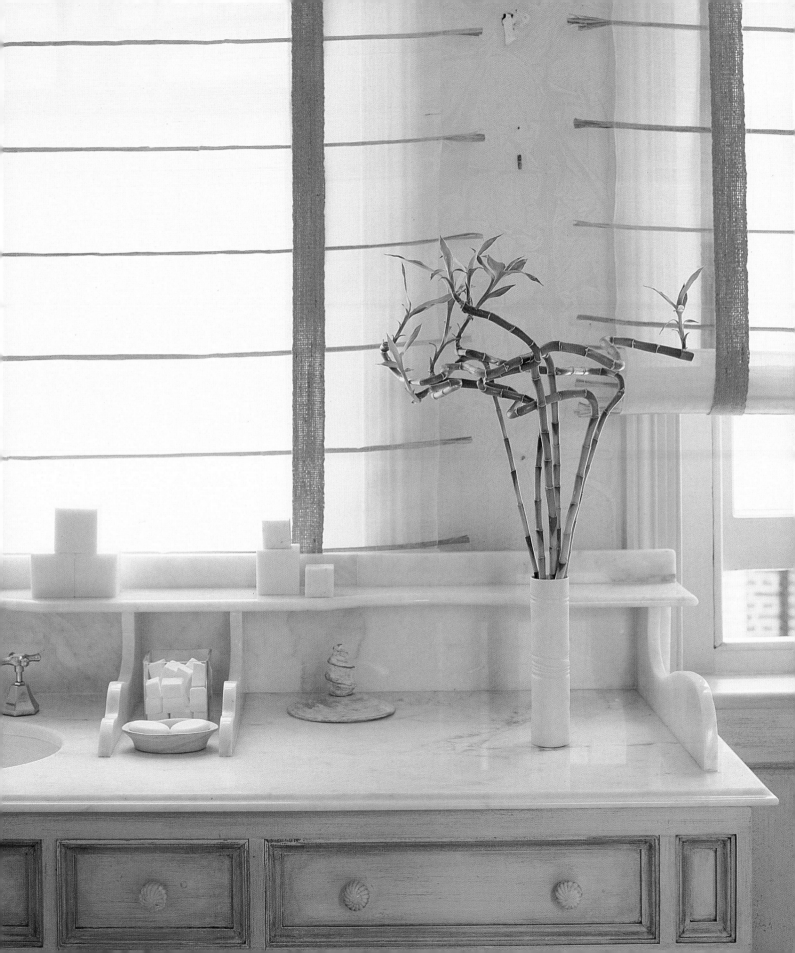

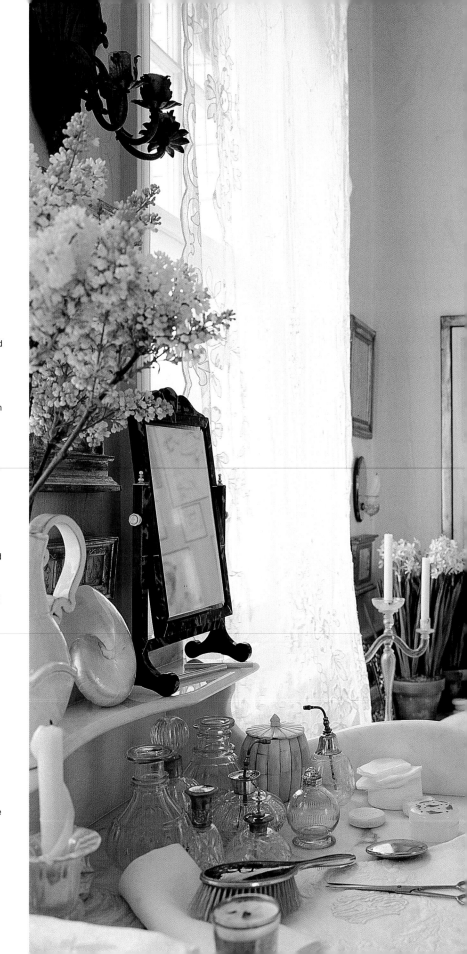

right This was how my
bathroom looked before
its makeover. Although
there was hardly room to
put anything down, I loved
the romantic clutter and
old-lace look, and all the
memories associated with
each item. The walls are
still a cracked creamy
colour specially mixed for
me by Jo Minoprio, a
specialist paint-effects
artist. She also painted
the cornices in cream and
distressed gold to match
the paint finish on the old
wood vanity unit, holding
all my bits and pieces of
crystal and glass. On
other walls, narrow fitted
cupboards hold unsightly
clutter, their mirrored
panels reflecting the
cream and gold theme.
This bathroom gives the
lie to the belief that white
rooms have to be stark
and clinical.

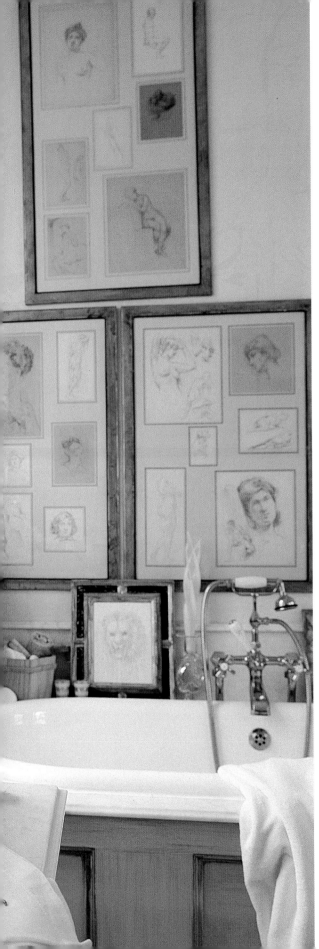

right and below right

I stocked the bathroom with my collection of crystal and glass perfume bottles and decanters, not because I wanted to fill them with bath oils and shampoos, but because they fitted in well with the overall look.

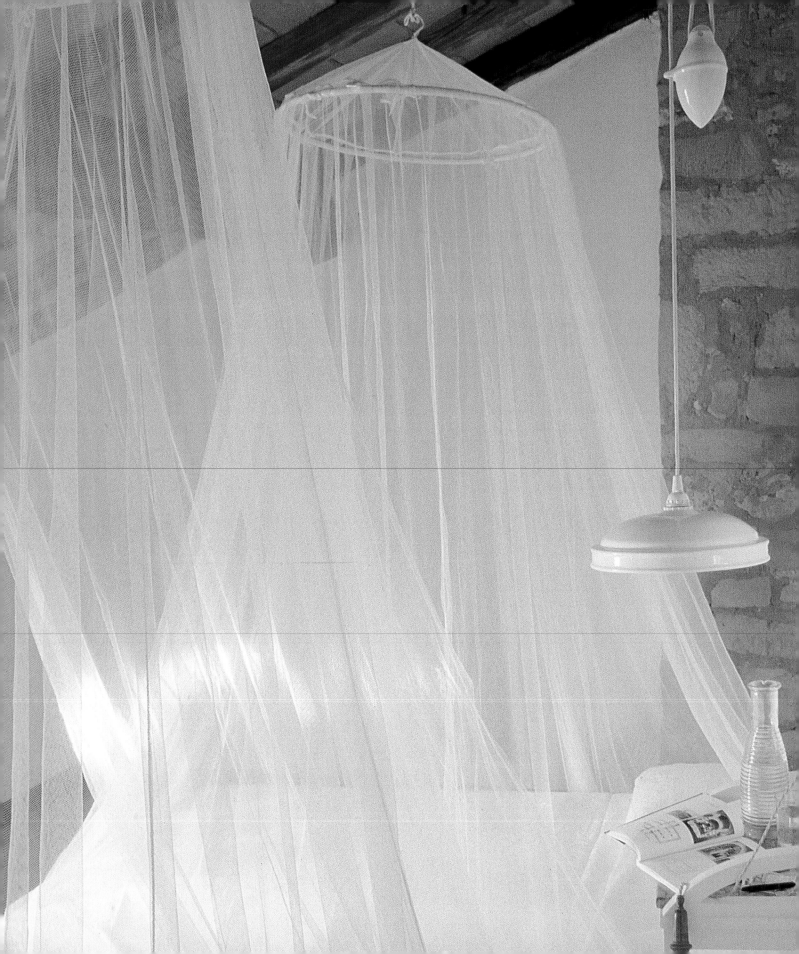

Summer

The summer take on white is crisp, clean, clear and ice cool. On the one hand it is heaps of starched white napkins on shiny surfaces that have the cool gleam of ice. And on the other it is massive white crocks filled with thick cream, and huge platters piled high with meltingly light, snow-white meringues. It is massed white sweet peas in glass vases, filmy muslin mosquito nets suspended gracefully over beds, wide-brimmed white straw hats, and hammocks of thick woven cotton hanging from boughs laden with apple blossom.

Summer is whites that shimmer like silk, and cloths from India embroidered with tiny mirrors that flash and sparkle. In fact, reflections in glass are very much part of the play of summer light. Think of thick glass bowls filled to the brim with pieces of nougat or white sugared almonds, and armfuls of fragrant white roses.

The textures of summer range from the smooth and sleek to the rough and soft, from the gleaming sea to the sandy shore. There are waffle-weave towels in the bathroom; and in the bedroom, warm duvets have been stored away in favour of antique linen sheets with intricate embroidered initials and simple quilted coverlets just thick enough to keep out the night chills.

Underfoot, rugs of bleached sisal or jute add sandy tones.

The dining table is covered with crisp white cotton, fine white porcelain, and glass candlesticks and is perhaps, for a special occasion, sprinkled with flower petals. Surfaces are decorated with large, sculptural shells or heaped with utilitarian objects such as a collection of spools from ancient weaving looms or a series of hat blocks from a long-forgotten milliner's shop. Glazed cotton cushions soften the seating areas. As the summer nights draw in, electric lights glow through parchment-coloured shades and candlelight flickers from Moroccan lanterns or old charcoal hand-warmers strategically placed at floor level so that stars dance on the ceiling.

The accent colours for white in the heat are the cool, strong greens of summer foliage, the icy silver of mirror glass and the turquoise blue of the sea crashing onto the beach of our dreams.

white
heat

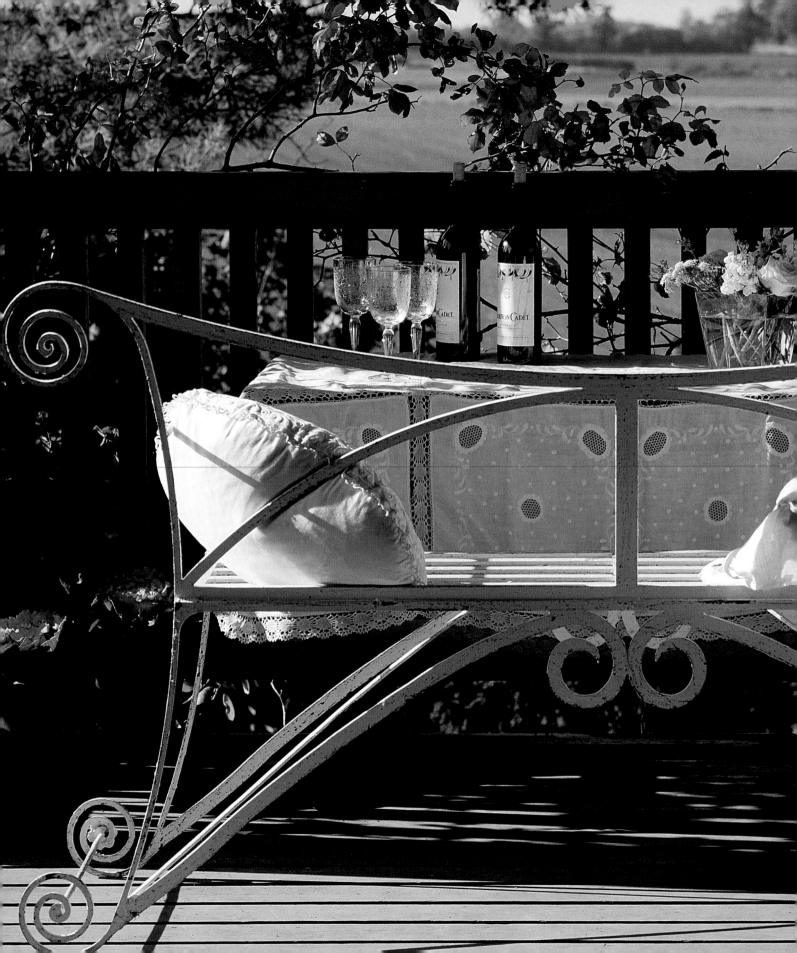

summer
essentials

Sunshine is, of course, a summer prerequisite,

which is accompanied by that feeling of being

able to open up the house and let the inside

tumble out. When we migrate out onto decks

and patios, balconies and terraces, we want to

take our home comforts with us. For me, the

thought of perching on a synthetic microfibre

cushion welded to a plastic chair and drinking

from a plastic cup is contrary to the whole

spirit of summer. I prefer garden furniture

that can live outside all year round – that

means choosing cast iron or hardwood – and I

take as much trouble with my outside table-

setting as with a setting indoors. I like to put

cut flowers on the table in glass or porcelain

vases, and to serve food on sturdy white china.

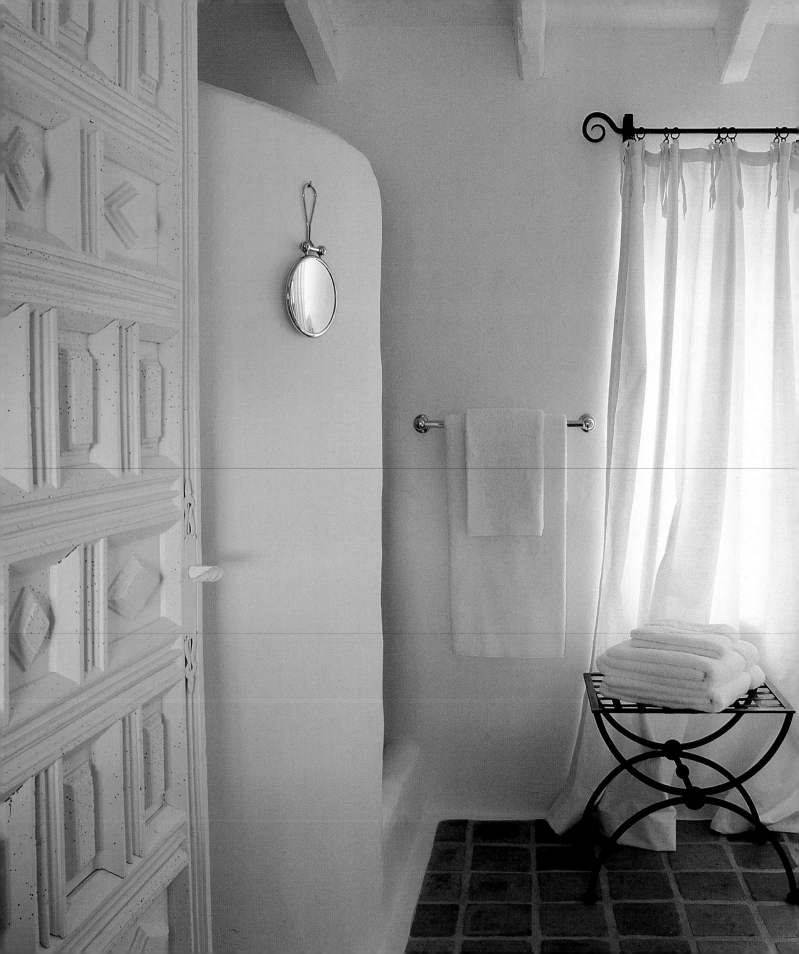

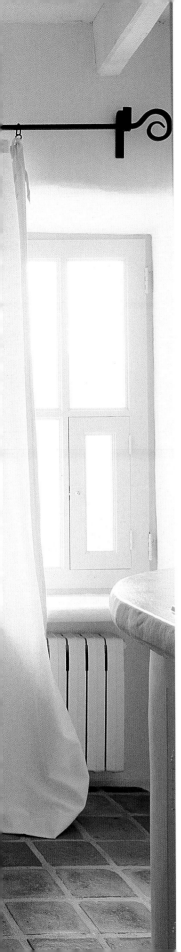

left Designer Mimmi
O'Connell chose a
distinctly white theme for
the decoration of each
room in a Marjorcan
farmhouse, which
emphasizes the colour
and simplicity of the local
terracotta tiles used on
the floors. In this small
bathroom, the simplicity
is enhanced by
whitewashed walls and
a painted rustic door.

above and left Natural
fabrics look marvellous in
white, whether bleached to
a blinding dazzle or left in
their natural, subtle tones.

cool
summer
linens

Each season sees more linen

appearing in the worlds of interior

design and fashion. I find it quite

extraordinary how this fabric has re–

emerged in the past decade: not only

is it a natural fibre in an age of synthetics, and a luxury fabric in

a world of denim, but also a fabric that, despite maximum

maintenance, always seems to be

creased! But linen hangs

beautifully, and nothing can match

it for look and feel. It is sheer

luxury next to the skin: nothing

equals the sensation of slipping

between freshly laundered, and,

yes, crisply ironed linen sheets.

below Linen's lovely, slightly coarse texture is subtly set off by this hand-embroidered monogram. The fabric's weight and draping qualities make it ideal for curtains.

above To me, linen is best in its natural colours, from off-white to ecru. Here, the simplest of drawn-thread borders emphasizes its cool good looks.

right I seek out old French linen sheets whenever I can and use them for curtains, duvet covers, and all sorts of other things. Whether completely plain or decorated with hand embroidery, they make the most elegant table linen, and the most sensuous bed linen of any fabric.

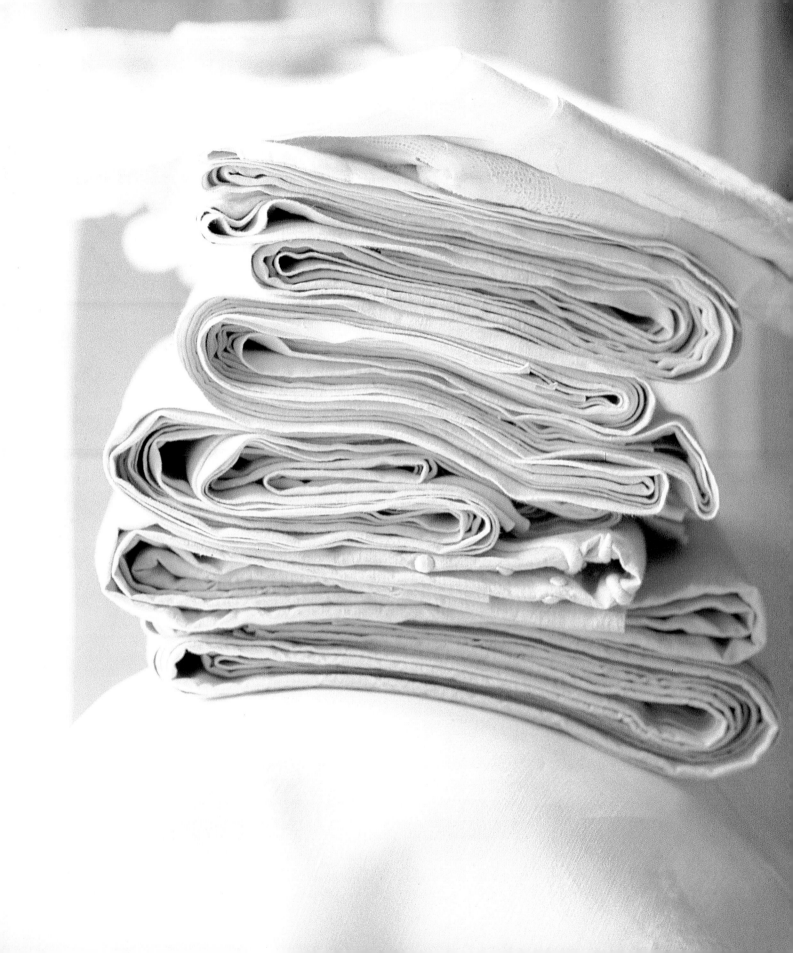

summer
flowers

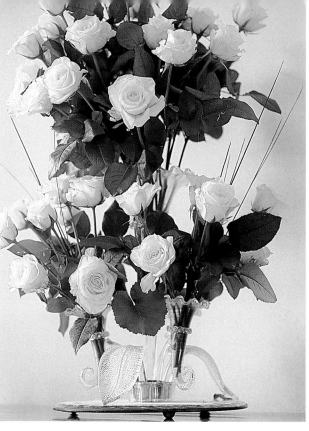

Of all the flowers available in the summer, I've always had a soft spot for roses. Because it is important in summer to bring the outdoors inside, I like to fill the house with flowers — maybe one stunning great armful as a focal point and then smaller bunches scattered about. There is always method in my apparent artlessness, and all the flowers are carefully chosen to paint the picture I want — such as using only white roses.

below Roses cut from a garden may be slightly blemished but they usually have a wonderful heady scent, while commercial roses are grown for uniformity of bloom and straightness of stem but lack fragrance.

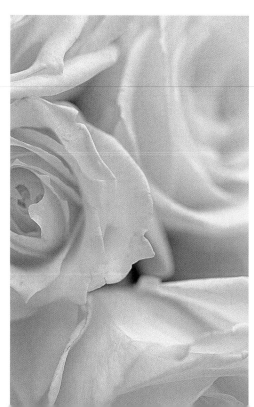

above This amazing hand-blown glass vase is a Victorian table centrepiece called an epergne – basically a tower of flute-shaped bud vases. London floral designer Rob Honey filled it with exquisite roses and grasses.

right In contrast to the showy elaborate arrangement above, this is sublimely simple – a modern square glass with a few short-stemmed blooms.

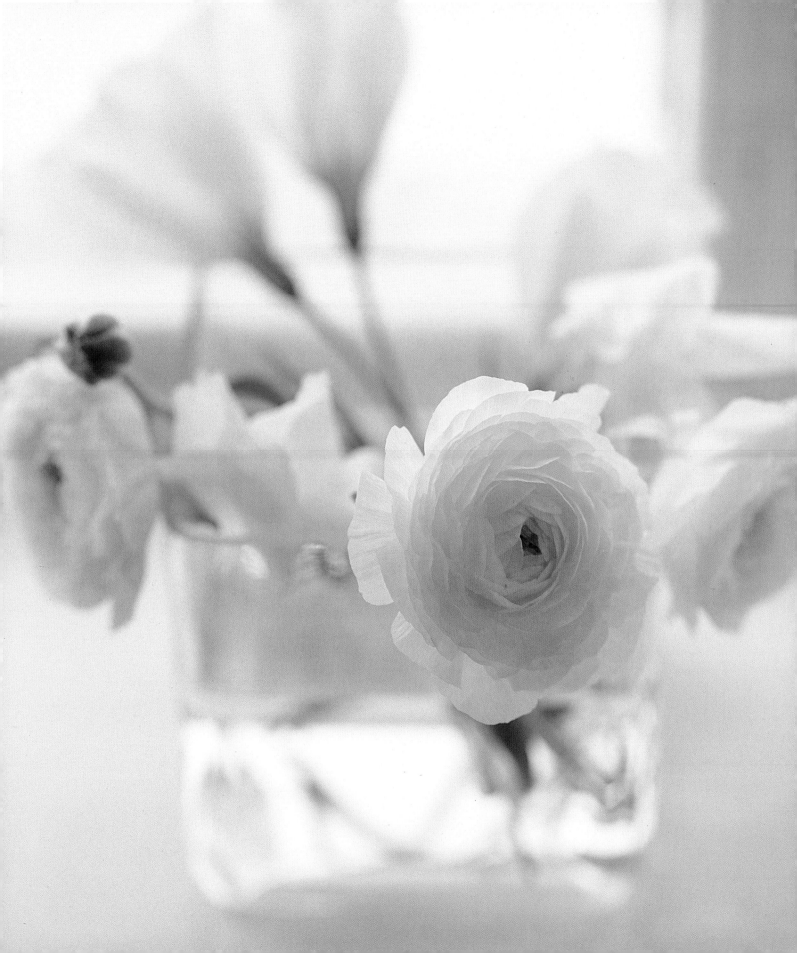

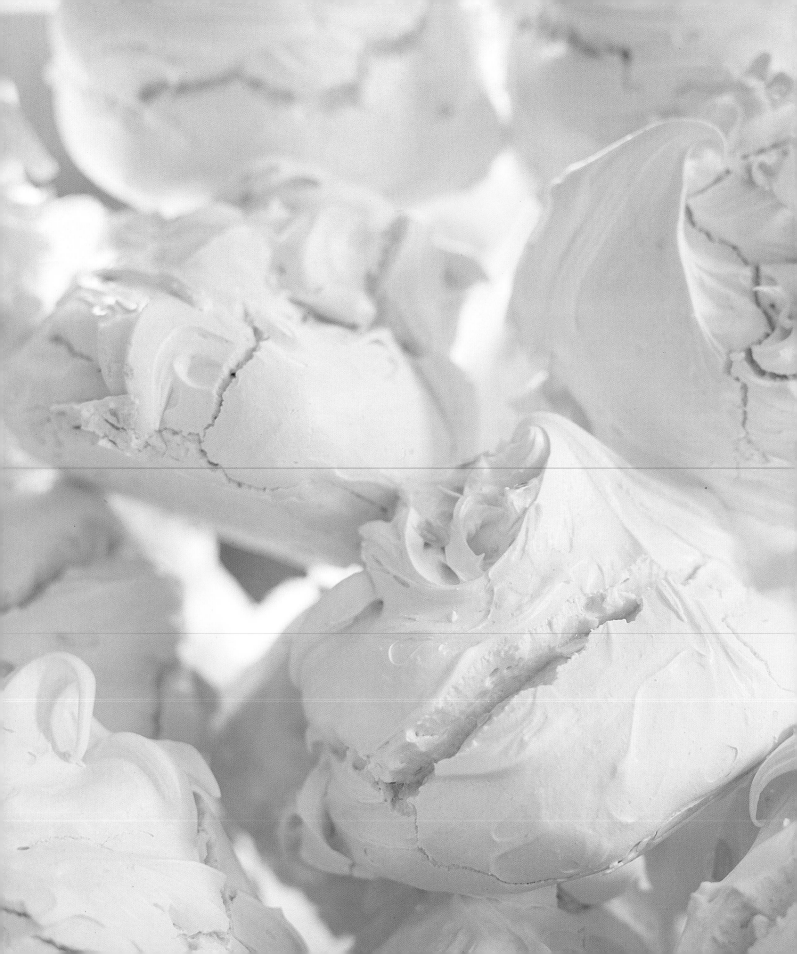

summer eating

Feasts at this time of year should definitely be held outside. Nature is a riot of colour in the summer, so imagine the visual impact of an all-white alfresco lunch with a hint of greenery, or an all-white picnic laid out in a verdant green field. There would be a crisp white cotton tablecloth and maybe, as a concession to the world of disposables, a handful of thick white paper napkins. Picnickers would sit around on thin cotton mats or on pale patterned blankets and cushions, while those dining at a table could enjoy the comfort of cushioned garden chairs. Amid the sparkle of glass and silverware, food would be dished up on simple white plates. As an hors d'oeuvre, I'd serve a pale vichyssoise soup, with a dusting of chopped chives, ready-chilled from a white thermos jug. For a main course I'd produce a beautifully poached chicken sliced into succulent portions, and served with a crisp green salad and crusty French bread.

Because the eye and the palate need a bit of variety, I'd probably toss in a roasted yellow-pepper salad which goes extremely well with chicken and looks very pretty. For dessert I'd choose a pile of snowy-white meringues, a bowl of thick cream, and a dish of strawberries, which would be a delicious visual shock in the monochromatic scheme.

I thought I'd produce something a little unexpected for the summer eating section of my book. I was looking for a new way to say

Meringues mean summer to me. I love the taste and I love the look of them. There are so many shades of white in a meringue, from the golden sticky bits on the bottom to the brittle white outer shell and the soft creamy interior.

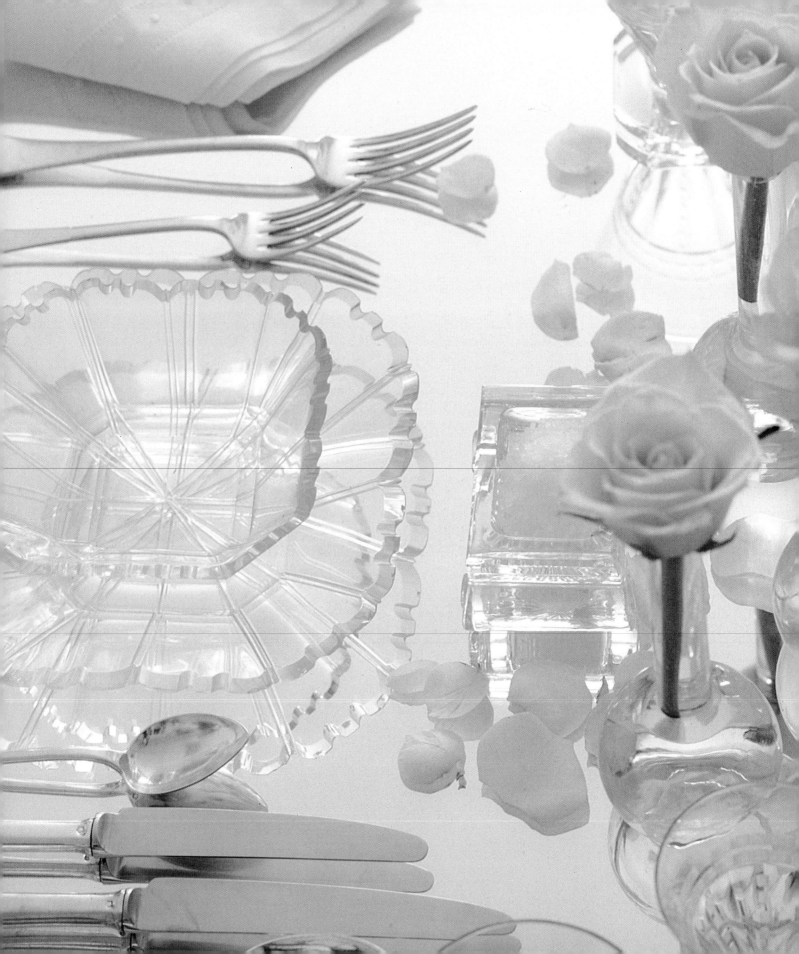

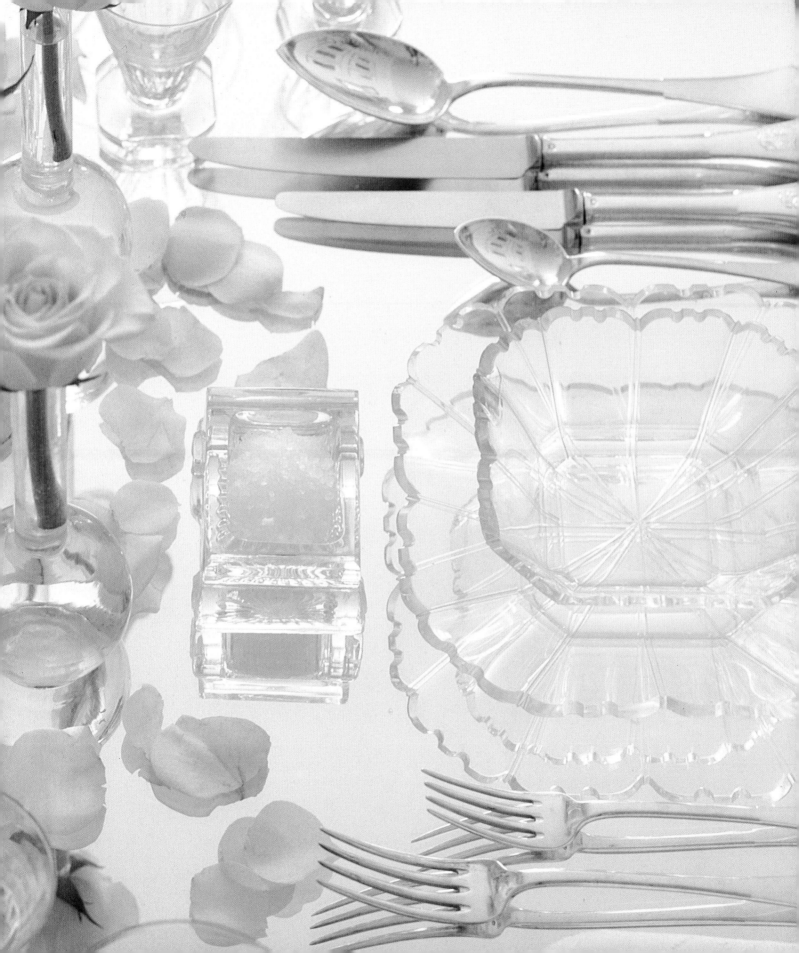

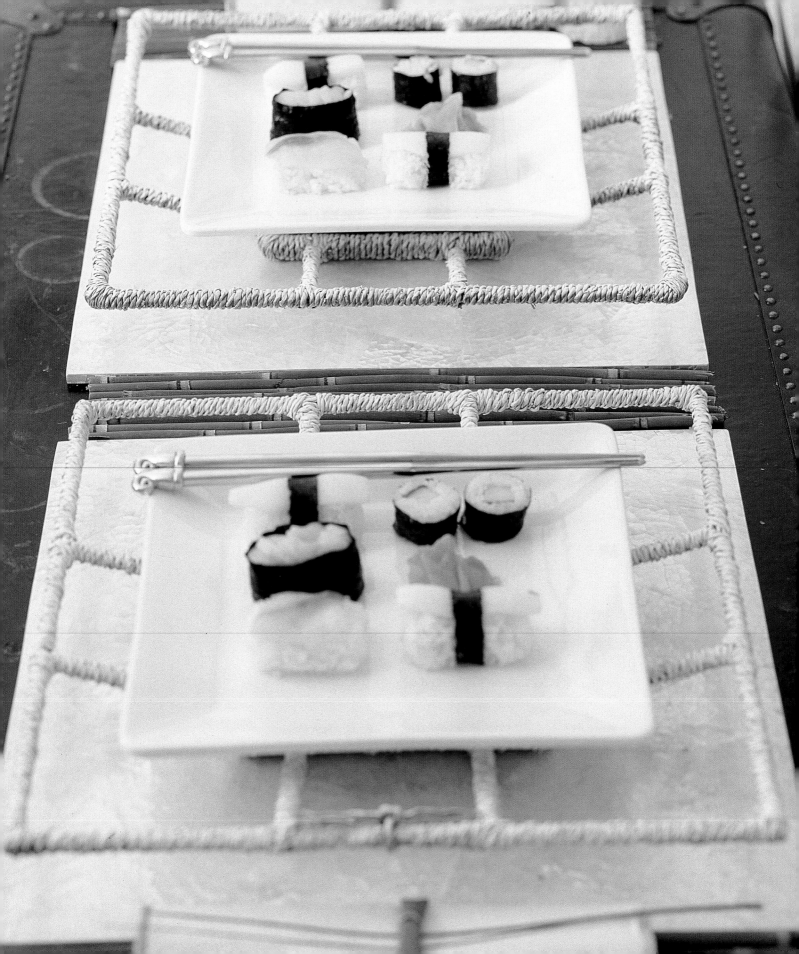

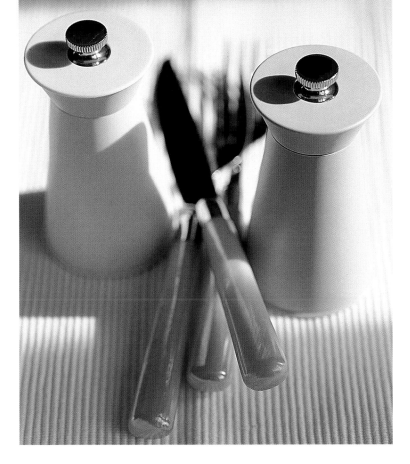

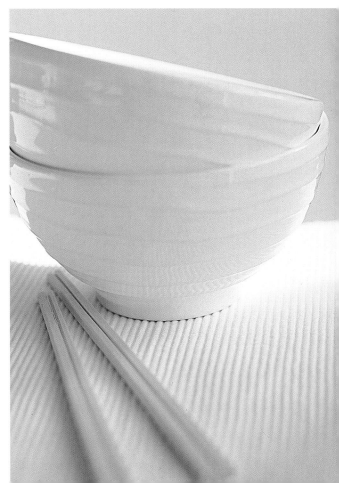

left The sushi setting is placed on a low leather trunk, about the right height for an authentic oriental floor-level feast. I used square white plates on square raffia under–plates. The beautiful silver chopsticks were a birthday gift from my daughter, Kelly.

left and below Detail and texture are paramount in the all-white setting, changing the way the light falls. Here, a white-ribbed cloth adds texture to the white table. You can see the contrast between the shiny salt and pepper mills, the pretty ridged bowls, and the matte chopsticks.

previous pages Nina Campbell's delicious summer table setting. The square glass plates in different sizes date from the 1920s, and the drinking glasses are from the '30s. All are from Nina's personal collection, as are the Viennese flatware and the glass salts. Nina has placed single white roses in crystal bud vases and sprinkled the table with rose petals – inspired!

summer white, and my dear friend the British interior designer Nina Campbell came up with one of her usual imaginative and stylish solutions. The ultimate setting for a sparkling lunch, Nina's summer table is laid on a mirrored surface.

In contrast, I went for the simple sushi setting shown here. I love the airy feel of the raffia underplates with the graphic order of the sushi.

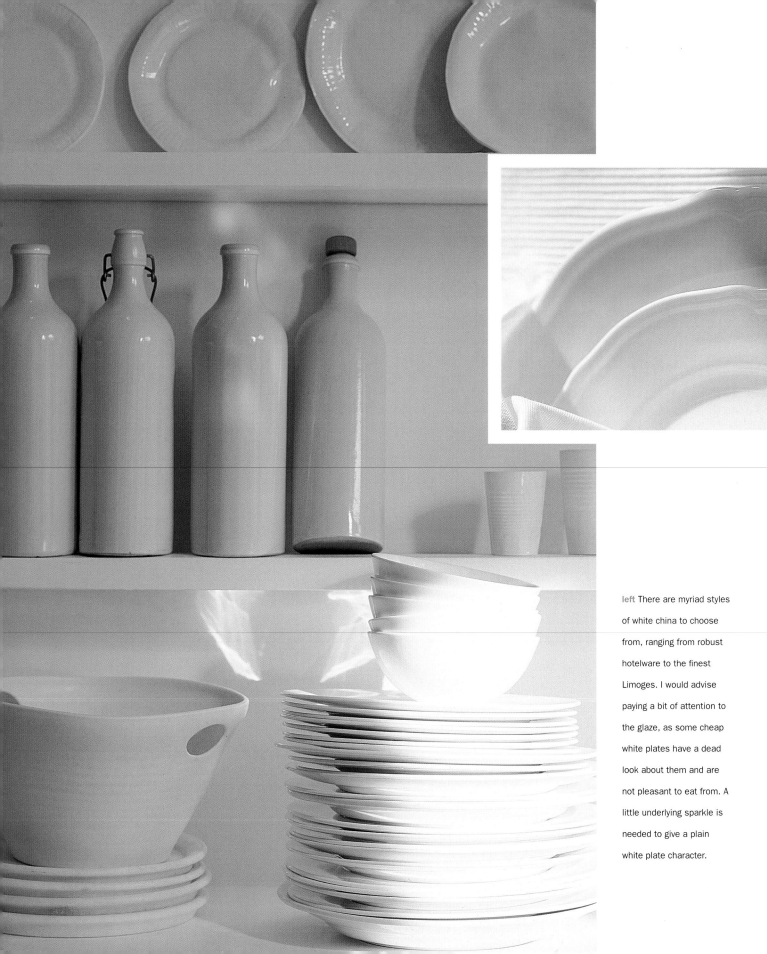

left There are myriad styles of white china to choose from, ranging from robust hotelware to the finest Limoges. I would advise paying a bit of attention to the glaze, as some cheap white plates have a dead look about them and are not pleasant to eat from. A little underlying sparkle is needed to give a plain white plate character.

left and right Rustic country china looks wonderful in white, with its bold shapes and solid feel. I'm also a fan of porcelain so fine and thin that it looks like eggshell. It all depends on the mood and the occasion.

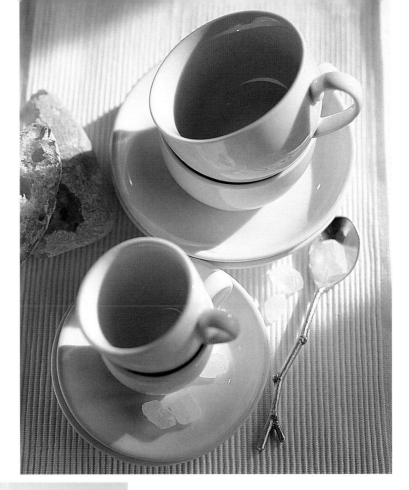

left Glassware is the neutral element of the white table – it is there to add sparkle and shine without adding to or detracting from the colour scheme. There is a wide range of specialist glassware. Apart from the obvious pieces, you can find stylish glass pepper mills, teacups, and even teapots.

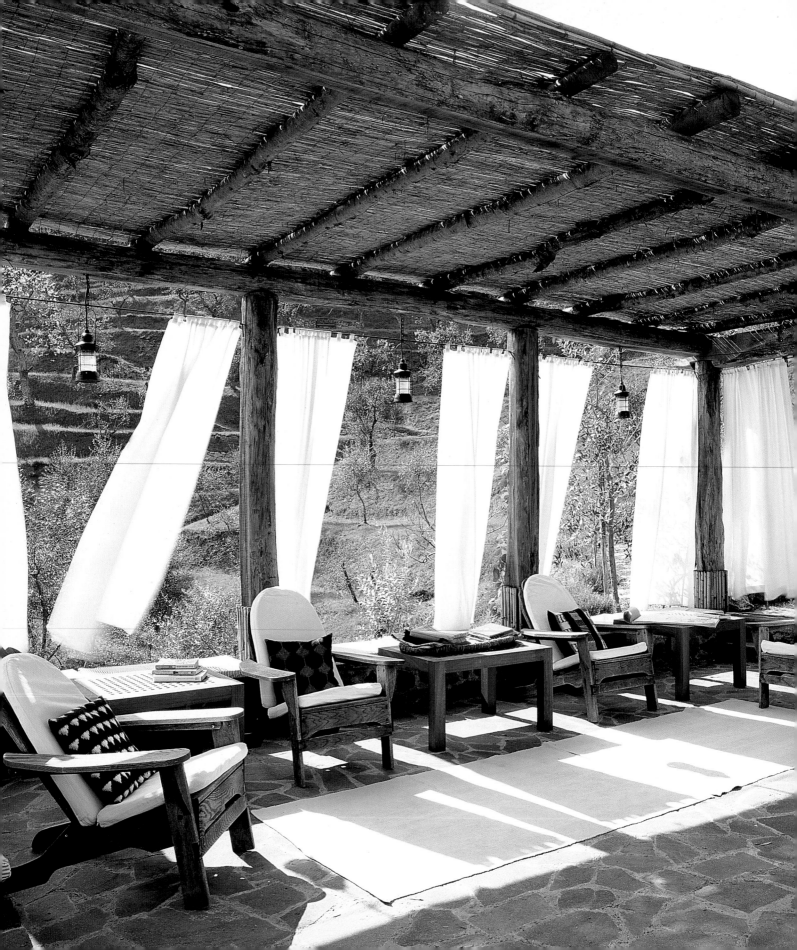

summer interiors

The aim behind choosing the summer interiors shown here was to find rooms that were sunlight-friendly, or rooms with a reflective quality — rooms, in fact, that would make the most of sunlight.

Very few rooms will look right all through the year, in every season, without a little bit of help from a change of curtain or cover. Most of us have to make do with the same living space all year round, but there are a few tricks for making seasonal changes, and going white and light for summer certainly brings out the dazzle. Maybe it is time to take down heavy winter curtains, leaving just a waft of muslin or a neat white shade at the window. Thick rugs can be replaced with pale jute runners or white cotton dhurries. A summer supply of cushion covers and throws will transform the seating in seconds. Taking down some pictures and swapping them for mirrors will bounce the light around in a new way and transform the room's character.

A crisp white linen duvet cover will turn a plain bedroom into a sybaritic summer spot. Bathrooms are easy to transform, too: just change the towels, get rid of the clutter, and invest in chunky, shiny accessories. Eating areas may benefit from a change of seat cushions and the addition of a pale tablecloth — a table top is a big area, and if you can lighten it up a bit, your all-year-round look will be subtly transformed.

left A pergola constructed from chestnut posts by designer Anthony Collett stands overlooking a swimming pool amidst the terraced olive groves of his house in Tuscany.

summer kitchen

This is the kitchen in interior designer Louise Bradley's chic but functional London pied à terre. The kitchen is small, but it has enough character for a room six times larger. The summery feeling is reinforced by the light streaming through French doors. When winter comes, one can always block out whistling draughts and views of sleet or a gloomy garden with a simple curtain on a removable pole. In the meantime, the French doors can be flung open at the first sign of sunshine.

This kitchen opens out onto a small balcony, and the table and chairs are light enough to be picked up and whisked out on a whim for breakfast or lunch alfresco.

inset A corner of Louise Bradley's kitchen. The little round hardwood table has acquired a lovely timeworn patina similar to the hardwood decking of the balcony. Silver-greys are an effective summer accent colour.

main picture Cream-coloured storage jars are ranged on a shelf in Louise's kitchen. Do not underestimate the power of shiny objects to reflect light around a room. It is not always necessary to rely on permanent solutions like coats of gloss paint or panels of mirror glass.

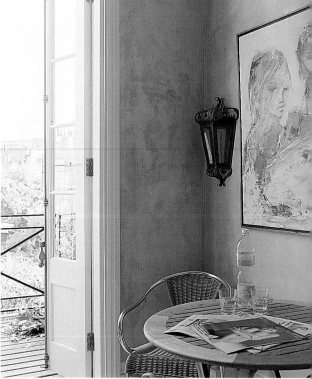

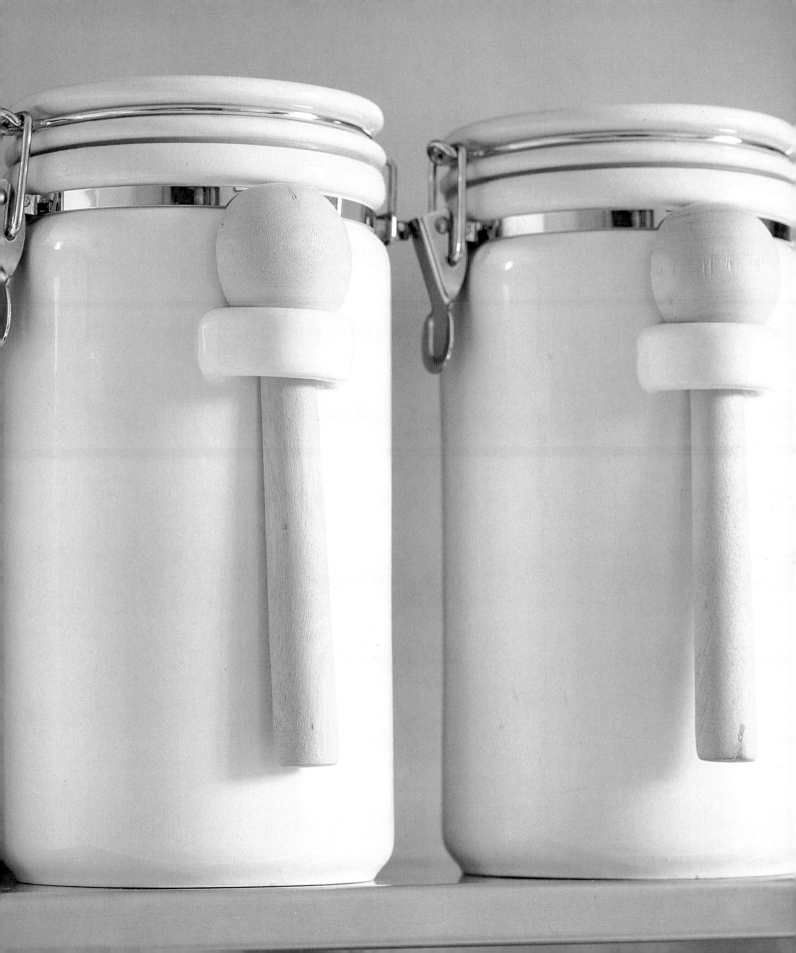

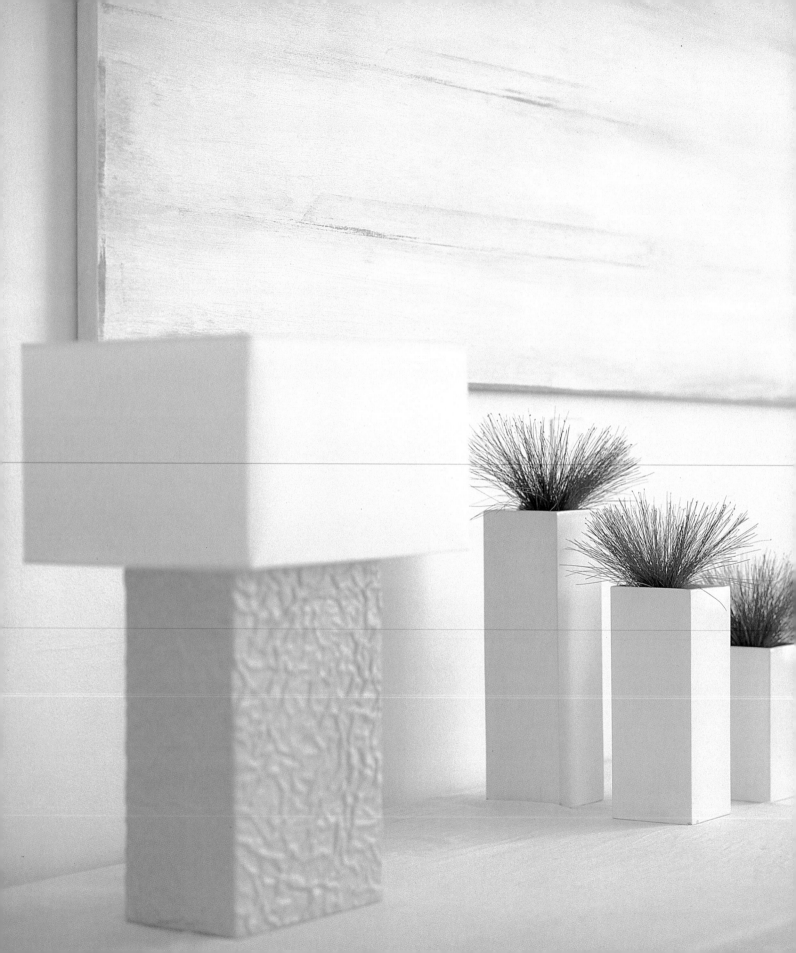

studio white

left A corner of John Carter's studio. White ceramic vases sprout tufts of bear grass, beneath a painting by James Maconochie.

below Hand-made plaster planter boxes stacked on a workbench. Give the arrangement a signature and it could be a sculptural installation.

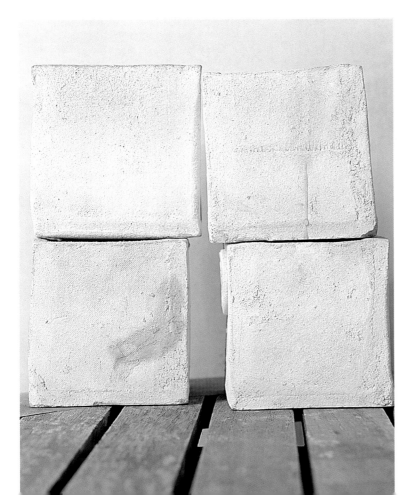

In the calm, white environment of his Chelsea, London studio, the gifted florist John Carter works on his innovative, sculptural, and totally unique creations using containers, planters, and vases. John can make a handful of grass look the chicest thing imaginable.

The space is amazing and its blank, expectant whiteness feels very creative. On one white wall there is a large white textured painting by the British artist James Maconochie.

It is John's awareness of the subtle interplay of texture and shape that puts him at the cutting edge of floral design. He commissions and collects vases and planters, most of which are, not surprisingly, in glass or various shades of white. There's no better foil for a plant.

white designer

This is my daughter Kelly's London studio.

It's in an old artist's studio in Chelsea. With

its huge north-facing window, the room is

flooded with light yet doesn't get too hot in

summer. The original pine floorboards have

been waxed — wooden floors and white walls

are the perfect backdrop for a designer.

left Kelly's desk is an intricately carved Indian table dating from the turn of the century. Her chair is a simple dining chair with a slipcover in linen.

right Bolsters and cushions on the bench seat are upholstered in calico. Runners made from scrim (a kind of rough hessian or burlap usually used in upholstery) have been tucked around each bolster and left hanging, so they're not a permanent feature. On the windowsill a parade of bay trees stands to attention in galvanized tin florist's pots. The unusual lamp base on the far table is made of limed (pickled) wood.

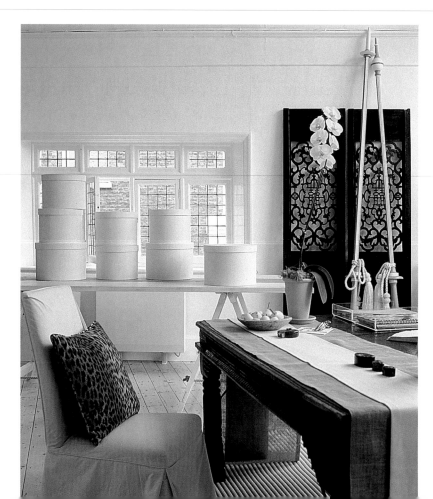

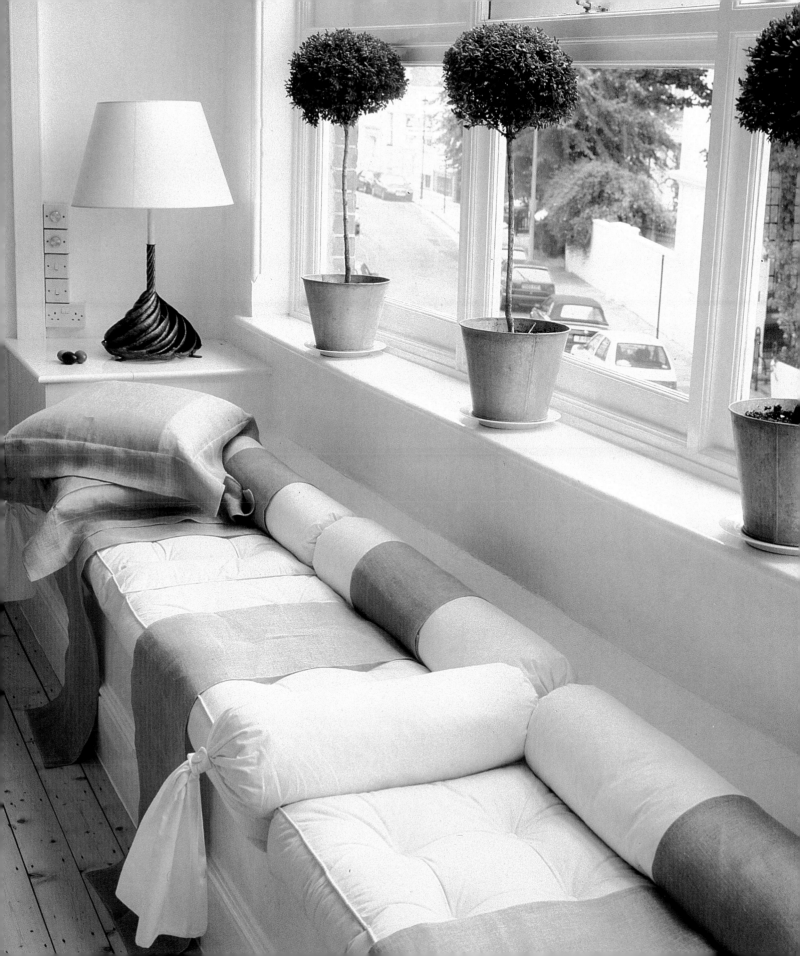

light white

Too much sunlight can be dazzling and uncomfortably hot, so in the summer, south-facing windows need shades or curtains that can be drawn against the glare and heat during the day, but still allow the light to flood in. Although thin, floaty fabrics look good wafting in the breeze, they will eventually rot through exposure to the sun. In fact, direct sunlight damages all natural fabrics.

My solution is not to live shrouded in darkness but simply to use cottons, canvases, and muslins, which are cheap enough that it doesn't break the bank to replace them when they start to fall apart.

left A beautiful handmade pleated shade by the British designer Stuart Hands is made of the thinnest starched linen. It gathers the sunlight and wraps it up like a gift.

left This quiet corner, in interior designer Jenny Phillips's London home, is protected from strong sunlight by the light-coloured curtain. The antique chair is simply upholstered in soft cotton.

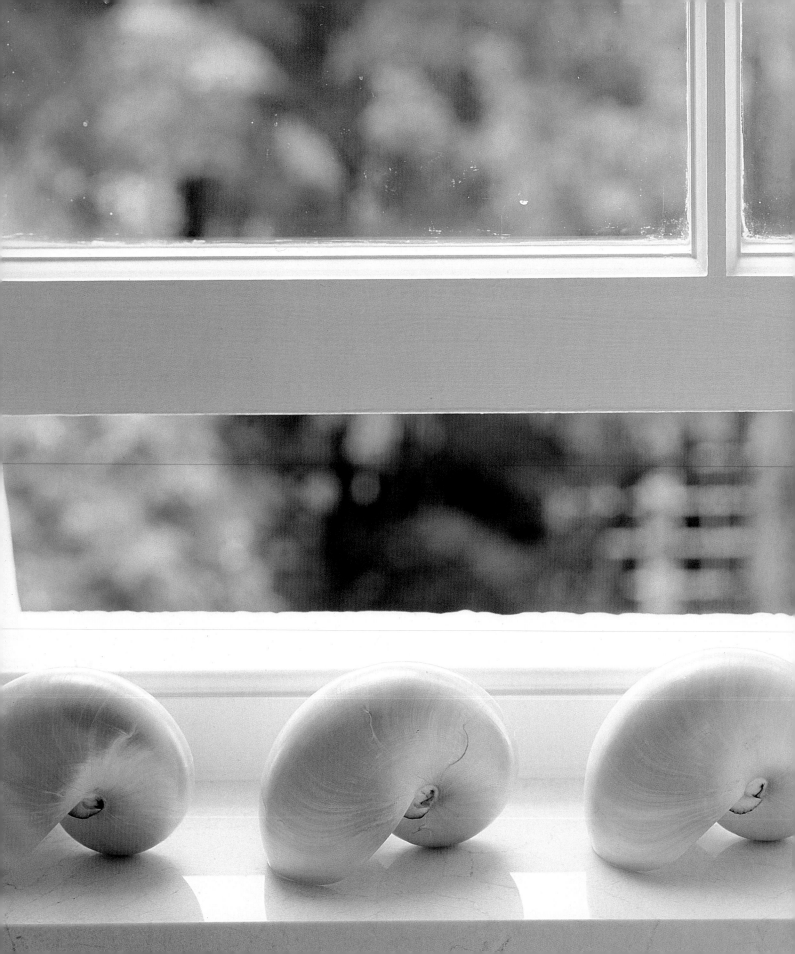

left A collection of Nautilus
shells on the marble
windowsill of a bathroom
designed by Jenny Phillips
illustrates the power of
repetition, particularly
when simply stated.

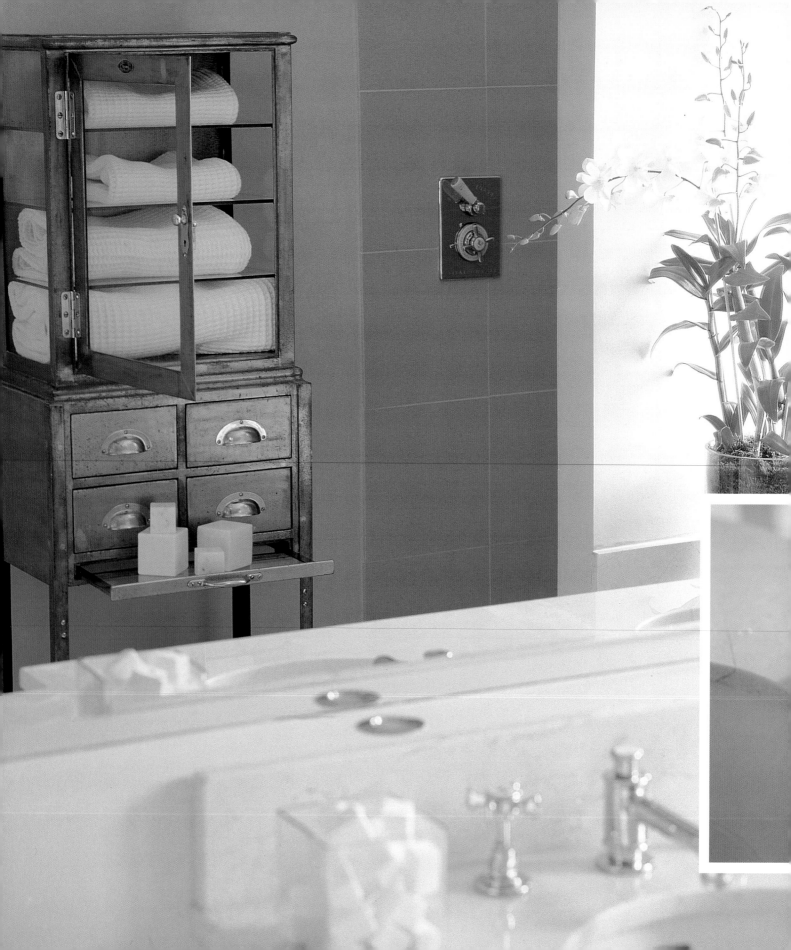

white
bath

left A polished dentist's cabinet is set against a wall of unpainted polished plaster. The white orchid, growing in a round glass vase filled with potting compost and moss, makes a pleasant change from the ferns and spider plants so often found in bathrooms.

below Generous chunks of handmade soap are virtually the same creamy colour as the marble and have a texture all their own. The round disc of shaving soap has such beautiful lettering stamped into it that it would almost be a pity to use it.

This lovely white bathroom, by the British interior designer Jenny Phillips, showcases an interesting array of whites and neutrals, from the warm-toned polished plaster walls to the unusually large, pale beige tiles in the shower, and the creamy marble vanity unit with its twin sinks.

The bathroom cabinet seen reflected in the mirror above the sinks is, in fact, a chrome dentist's cabinet dating from the 1920s. Originally these cabinets were enamelled, but this one has been lovingly stripped and polished and is now used for keeping spare towels to hand.

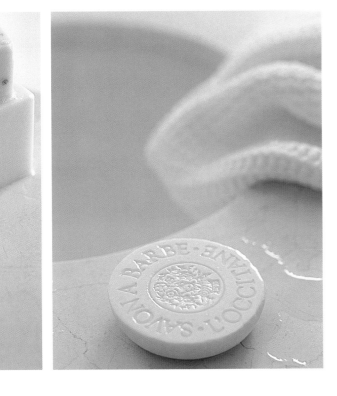

To contrast with the beige-coloured plaster

walls of the bathroom featured on the previous

two pages, the woodwork has been painted a

subtle shade of soft white. At the window, a

beautiful unstructured shade seems to float in

space. Another unique creation by the talented

Stuart Hands, it is made from unlined ivory

silk organza edged with silk dupion. The owner

has ordered several sets of these shades to be

made up, knowing that they will last only two or

three years before sun-rot sets in, but the effect

is stunning in the meantime.

The bathroom is large and has its own

fireplace. Screening the fireplace, and adding

its own sparkle to the scene, is a towel rail that

is a one-off designer piece made in the United

States in the 1940s.

right Thick, waffle cotton towels hang on a 1940s towel rail made of a material called Lucite – now known as Perspex or Plexiglass.

right Stuart Hands's gauzy shade hides a boring view of a brick wall. The use of fabric, marble, plaster, and paint in this bathroom is an object lesson in the potential spectrum of white.

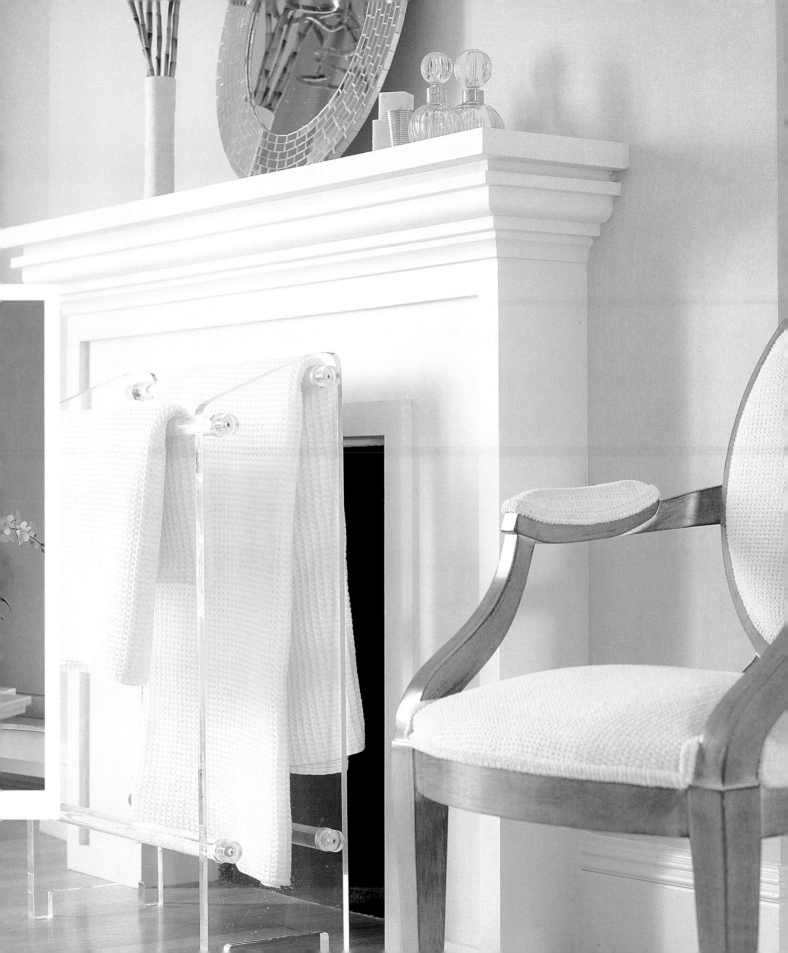

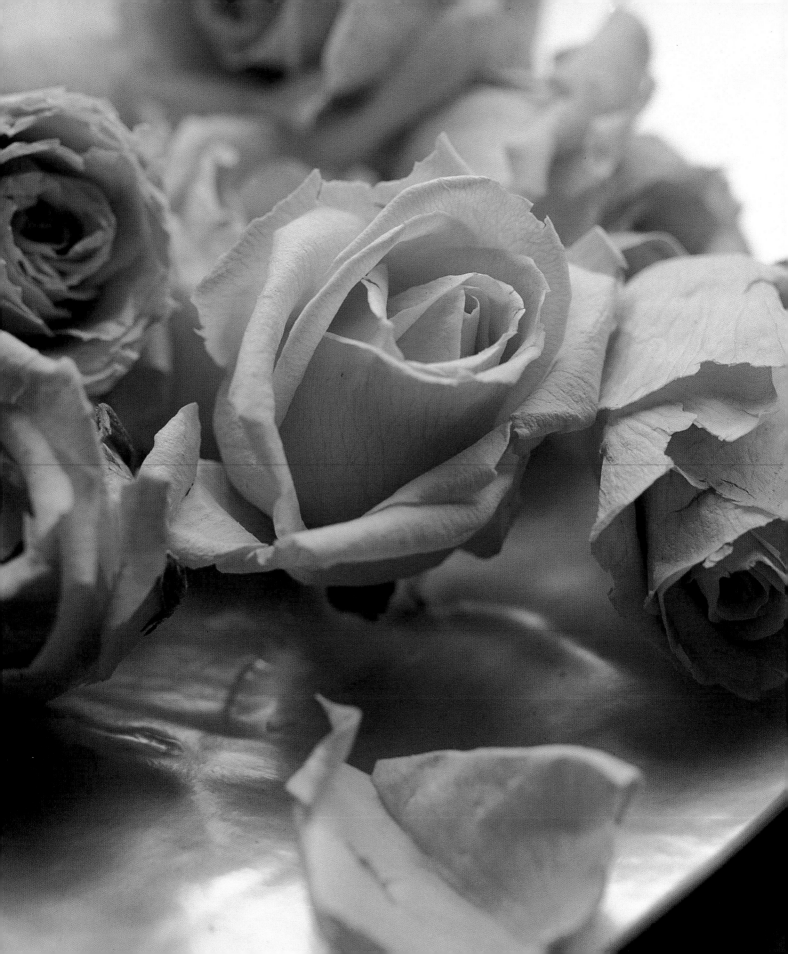

Autumn

When the mists roll in and the leaves start to turn russet around the edges, white can still be warming and welcoming. Think of the inviting ivory glow from beeswax candles, a teetering pile of toasted marshmallows, a sumptuously thick cream-coloured chenille throw, and a vase full of voluptuous white amaryllis scenting the air.

This is the season for soft, mellow whites and thick, warm textures, quilting, and fringing. Muslins, starched cottons, and fine linens now make way for woven textures in all shades of white, from rich cream to the papery white of a bleached birch log. Fabrics are soft and decoratively textured, such as white crewel work, in which patterns are embroidered with white wool onto a thick cotton cloth.

To tone down the reflective quality of white, which is so much part of the spring and summer feel, I like to twist and knot and tie plain fabrics to give them more of a feeling of three-dimensional texture. For autumn decorations and displays, I go for rubbed-down painted objects, thick handmade paper, old buckskin leather suitcases, antique decoy ducks — anything with a broken-up surface and an interesting, sculptural shape.

Nowadays, practically every variety of flower and plant is available, at a price, all year round, but I like to vary flowers and fruits with the season. To me, an autumn setting needs a reminder of harvests gathered in, perhaps with a copious pile of white custard squashes, white-skinned aubergines (eggplants), or bleached seed pods. For table decorations I might use dried and hardy elements like reindeer moss and heather with pale variegated ivy, papery sprigs of honesty, and dried white hydrangeas. A vase of full-blown late roses is another poignant acknowledgment of the end of the growing season and the beginning of long, dark, cozy nights.

Autumn highlight colours have to be the russet golds found in fallen leaves and autumn berries. White and gold look terrific together, and you can reinforce that rich glow of autumn with pale woods and natural wicker, polished floorboards and the flickering flames of an open fire.

white

gold

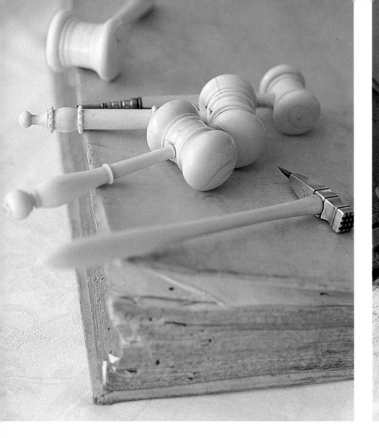
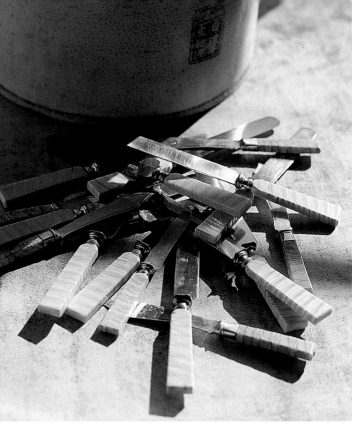

autumn
essentials

The whites I've chosen to show in this section

border on the creamy-beige. All the objects

come from the antiques shop Guinevere, in

London's King's Road. I know I've gone for a

more cluttered look here because I have to

confess that, as the nights draw in, so do my

hoarding instincts.

I think it is a good idea to keep

changing focal points and objects

in a room, but that doesn't mean starting

from scratch every few months and throwing

things away. It is more a question of recycling.

I find that you can get too familiar with even

the most beautiful things and there is nothing

like a seasonal break from a loved object to

make you appreciate it all the more.

above Two rare collections: one of ivory auctioneer's gavels from the 1800s, the other of distinctive stripey knives cut from antique mammoth tusks.

right Victorian silver and mother-of-pearl flatware is displayed in an elegant ivory vase.

overleaf These antique ivory and bone pepper mills, many banded in silver, date from 1900–1920.

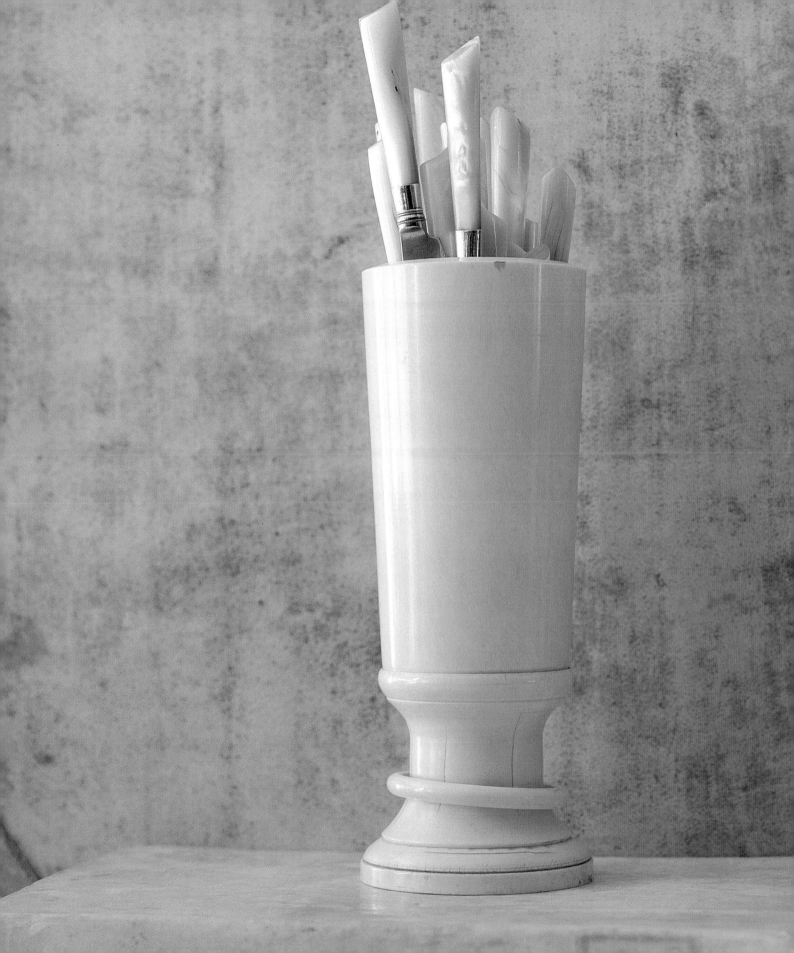

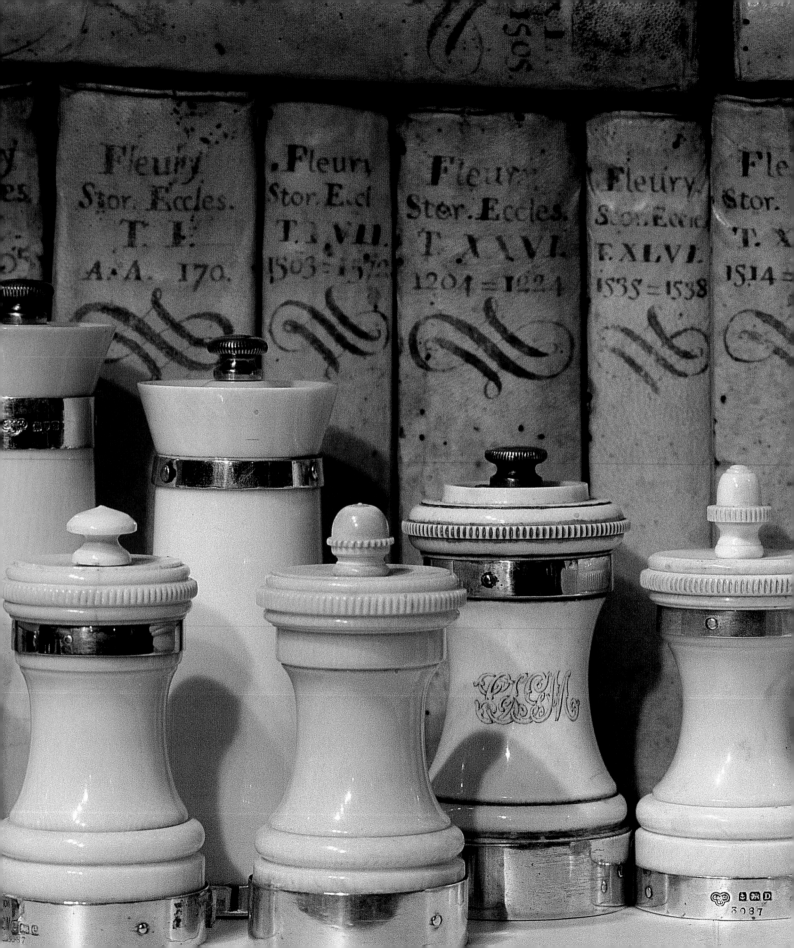

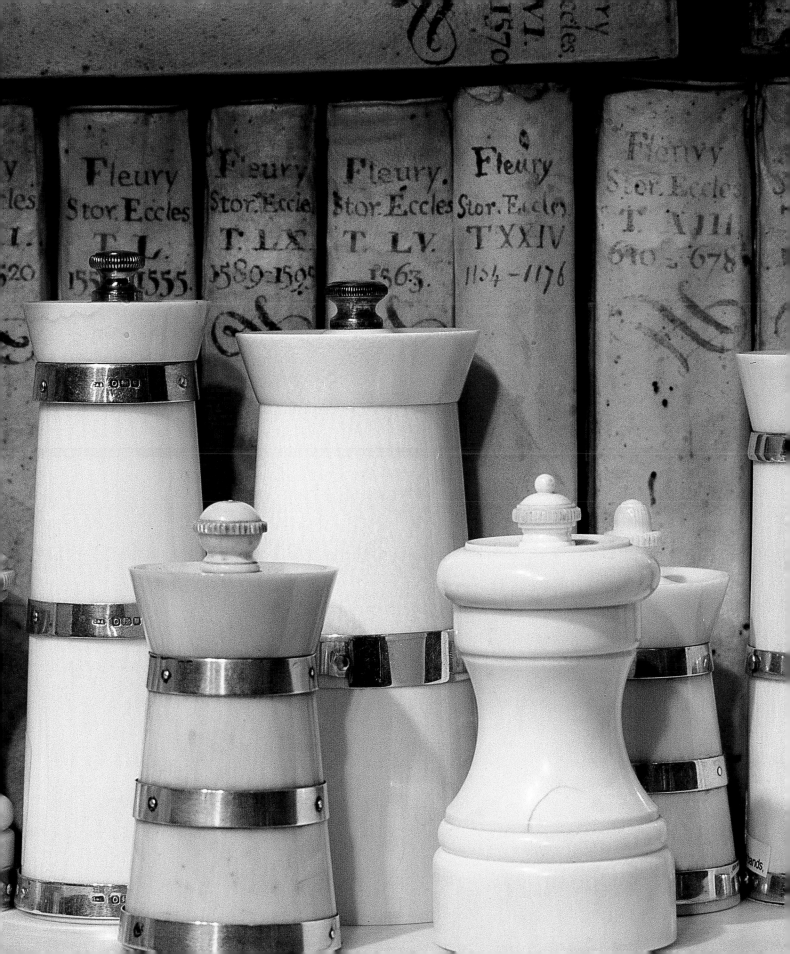

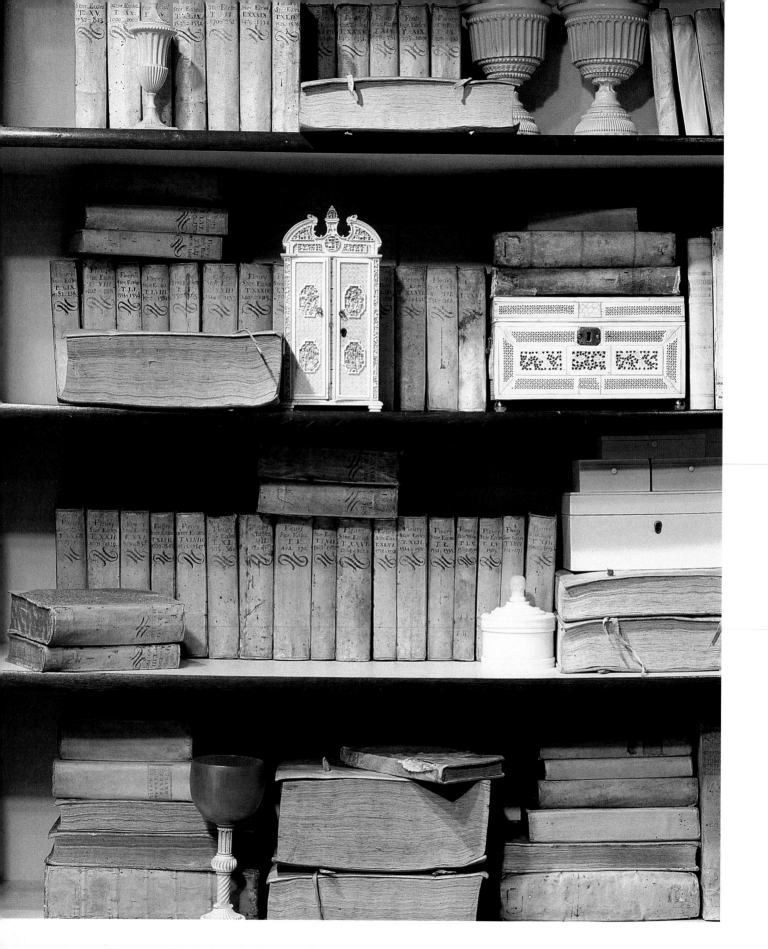

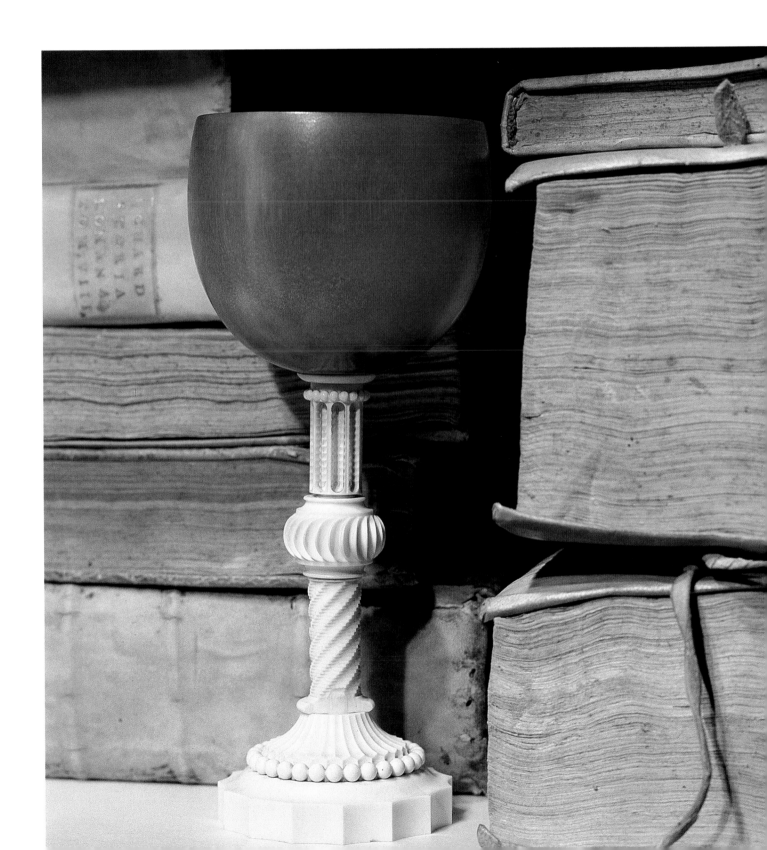

comfortable
textures

left and inset This curtain, matching blind and bed throws are made from hand-embroidered cotton.

previous pages These vellum-bound books are prized by both collectors and decorators for their colour and texture. The books themselves – serious tomes on religion, astronomy or science dating from the 1600s to the 1800s – are usually fairly unreadable. Here the books have been interspersed on the shelves with white and creamy objects. The vessel on the right is an antique ivory and bone chalice from the 1800s.

Forget the starched linens and plain floaty cottons of summer. Autumn is the time to enjoy the rich textures of quilting, embroidery, tassels, and fringes. On the page opposite, you can appreciate the tactile quality of some gorgeous hand-embroidered fabrics from the London fabric shop, Chelsea Textiles.

It is a great comfort to find handmade articles in this mass-market world. I have actually watched fabrics like these being made in India, and it was fascinating. The embroiderers, all men, sat cross-legged in a bright, airy "factory" embroidering patterns sketched out on the fabric by the "master". Every time I see these fabrics I remember those cheerful, talented men and the sight of their needles flashing away at amazing speeds.

One of the bonuses of choosing fabrics within the white on white palette is that everything goes with everything else, whether it's a wisp of French voile or a sturdy woollen blanket from South America.

below Almost unbearably
cute – white leather
babies' boots are perched
on a sisal stair carpet.

above Tiny glass beads
would make an unusual
fringing on a white throw.
Choose beads like these
that are round, smooth,
and sturdy. Anything more
delicate or trailing would
be a recipe for disastrous
snags and scratches. Soft
woollen pompoms look
good as a trim around big
squashy pillows.

right Fringes, knits. and
narrow pleats are the
perfect ingredients to
make autumn soft
furnishings as cozy as
they are stylish. I love
the knitted cushion cover,
which is as comforting as
a well-loved sweater.

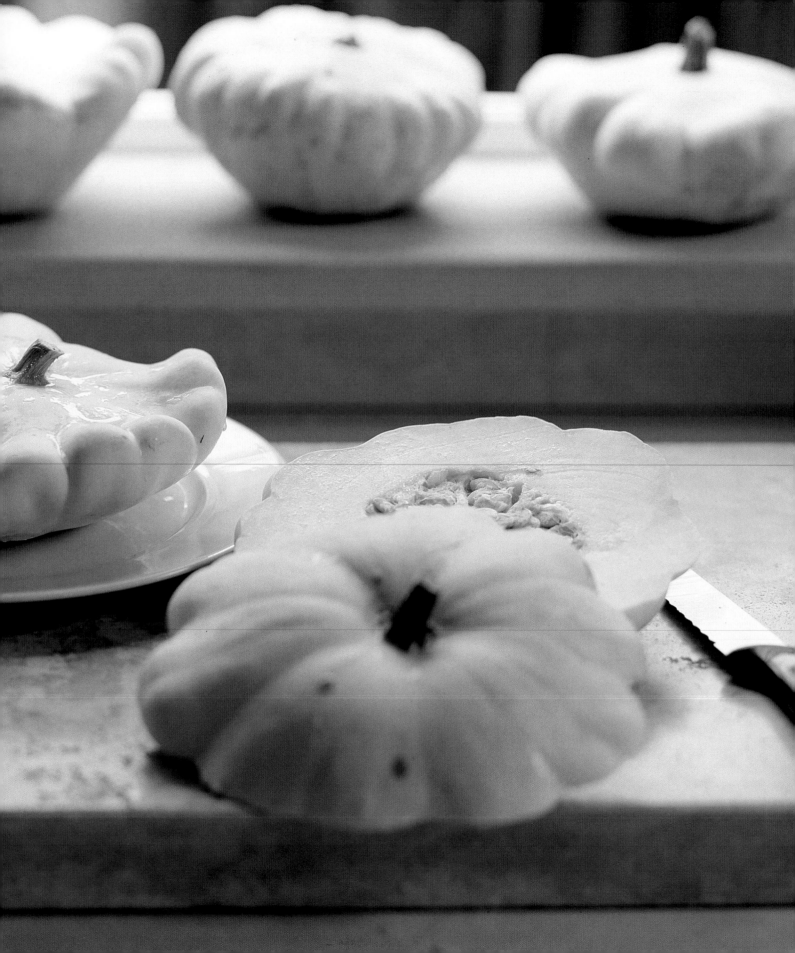

autumn foods

White food is not quite what you would expect to eat on a crisp autumn day with a hint of a chill in the air, but there are certainly plenty of interesting fruits and vegetables you can use to decorate a table or pile up as a still life. I love using vegetables as a decorative feature. They can often be more interesting than fruit, flowers or plants.

The amazing vegetables shown opposite are white custard squashes, also known as white custard marrows or pattypan squashes. They are best eaten when small but very ripe. Regardless of their flavour, however, I think they look absolutely stunning in profusion.

They resemble little pies made out of fine ceramics by an eccentric artist, each with a jaunty character of its own.

Seasonal white foods can range from soft, creamy brie or camembert with their succulent yellow centres bursting with flavour, to juicy winter berries, pungent, woody mushrooms or feather-light cakes dusted with icing sugar, still warm from the baking tin. Even a cottage pie topped with fluffy mashed potato, a home-baked loaf, or a steak and kidney pie crowned with flaky pastry, add a warmth to a traditional white-on-white table on a wet autumn afternoon.

left Many autumn vegetables are highly ornamental, such as these white custard squashes, which make an attractive alternative to flowers in a white on white scheme.

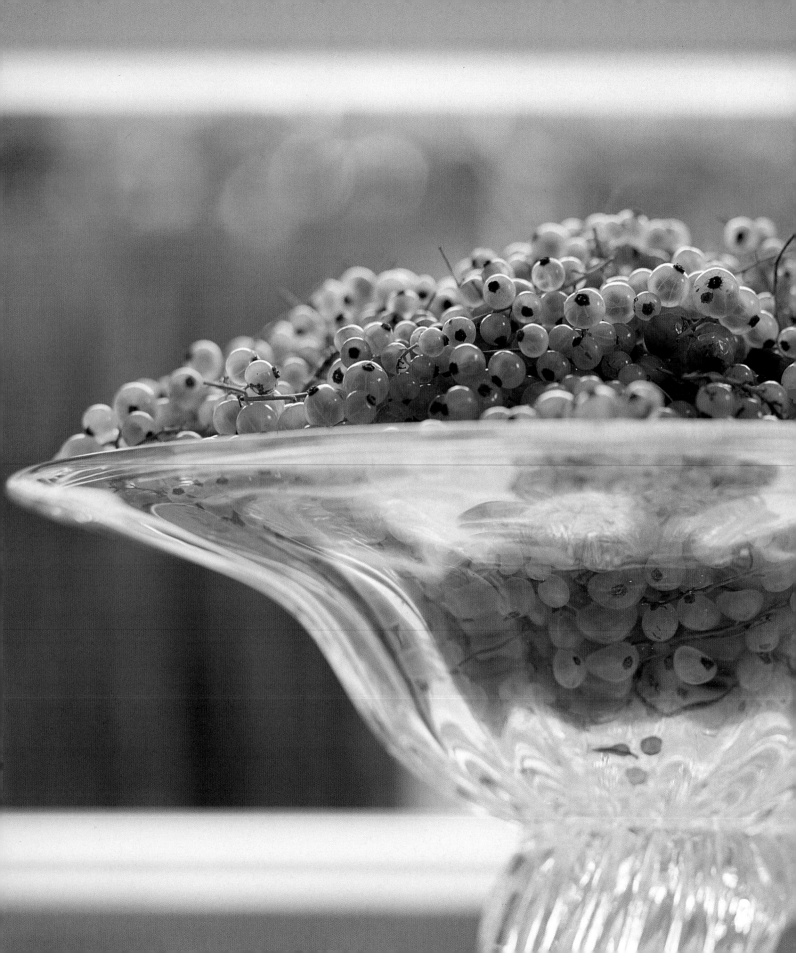

this page White currants, the pearls of the fruit world, are piled high in a large glass bowl handmade by the British glass-maker, Anthony Stern. White currants don't taste great but they make a perfect centrepiece for the autumn table.

overleaf left Moving into the realms of the not-just-edible-but-perfectly-delicious, a beautiful creamy Camembert cheese is served up on its white waxed-paper wrapping.

overleaf right A bowl of little white button mushrooms is the culinary version of a pile of polished pebbles.

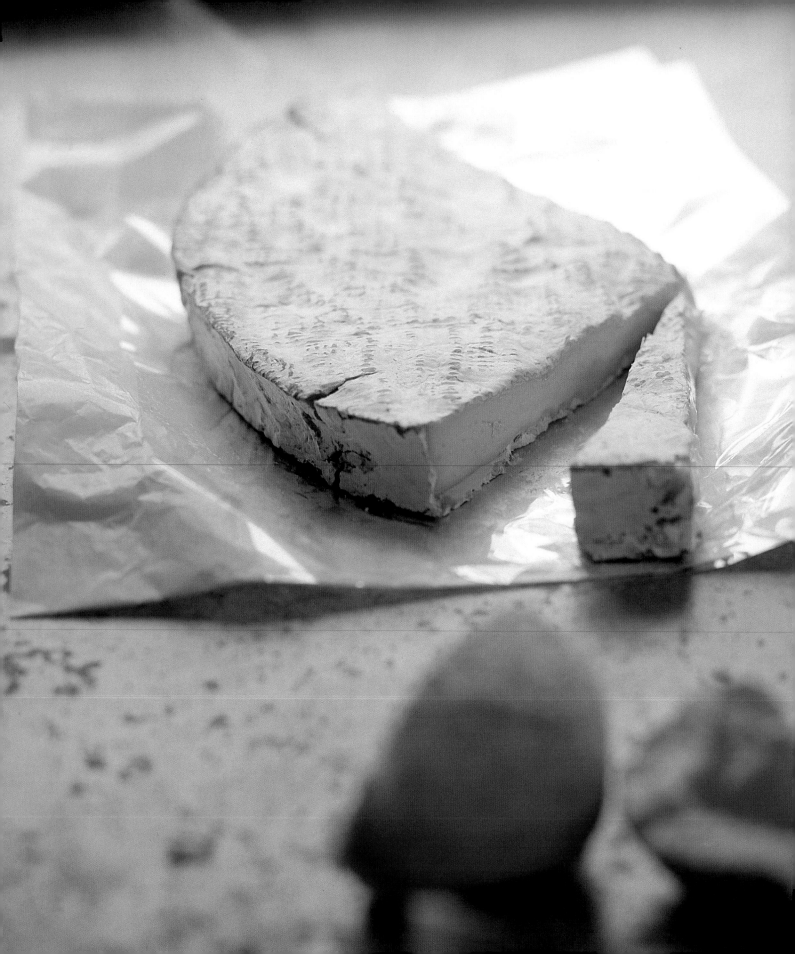

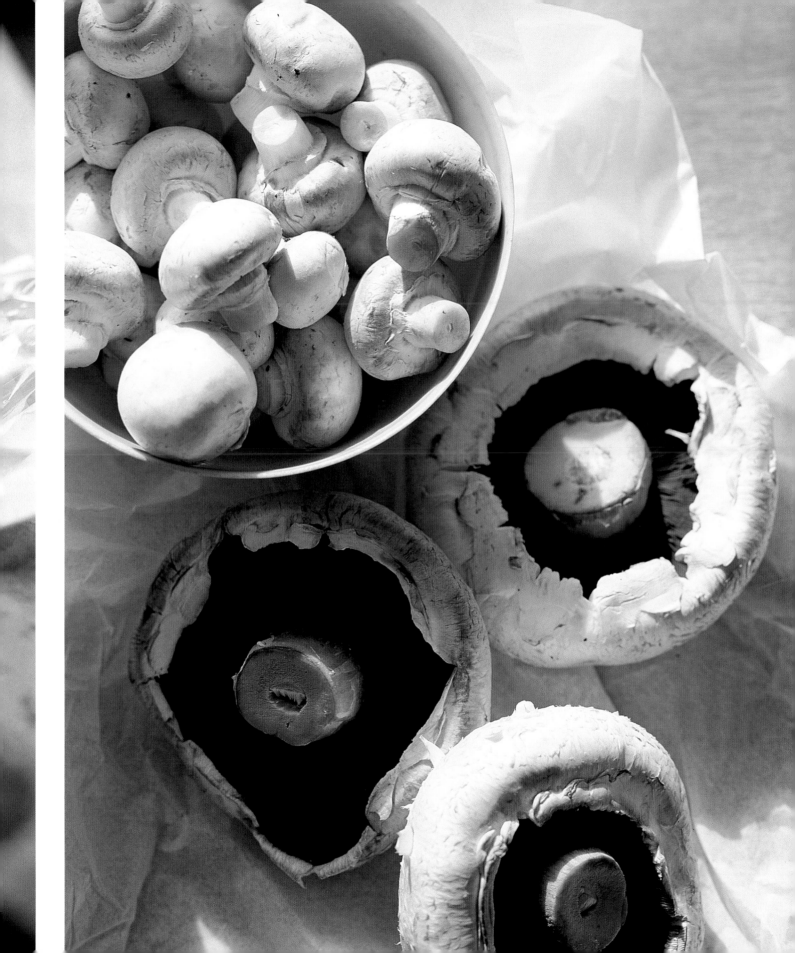

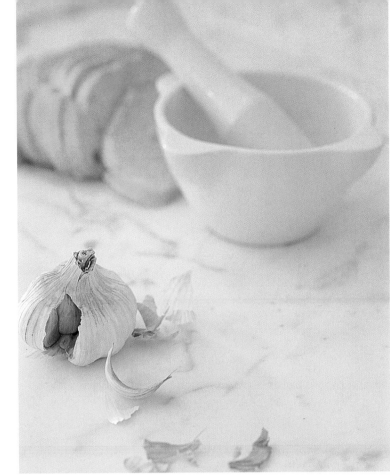

right and below A marble sideboard looks wonderful, and in these photographs we have teamed it with simple, chunky kitchen essentials – a lovely pestle and mortar and a pair of fabulous oil and vinegar bottles. The cork pourers in the bottles are an absolute godsend. I buy them by the handful from French market stalls, where they cost practically nothing.

left Food and drink are essentially so colourful that they are best appreciated against a background of unfussy white. Here an unusual glass teapot allows the delicate infusion to be fully appreciated. White bone china is a perennial favourite.

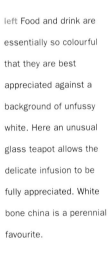

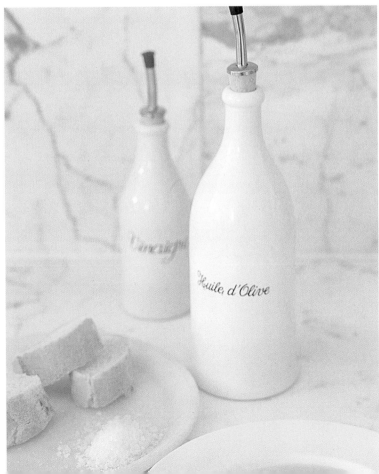

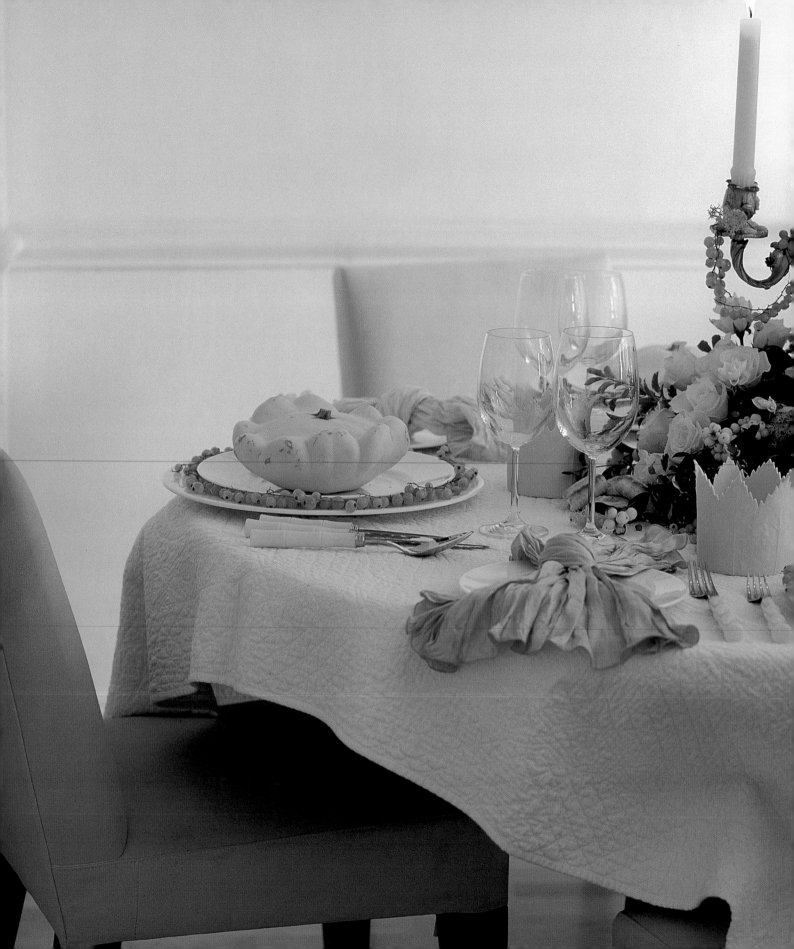

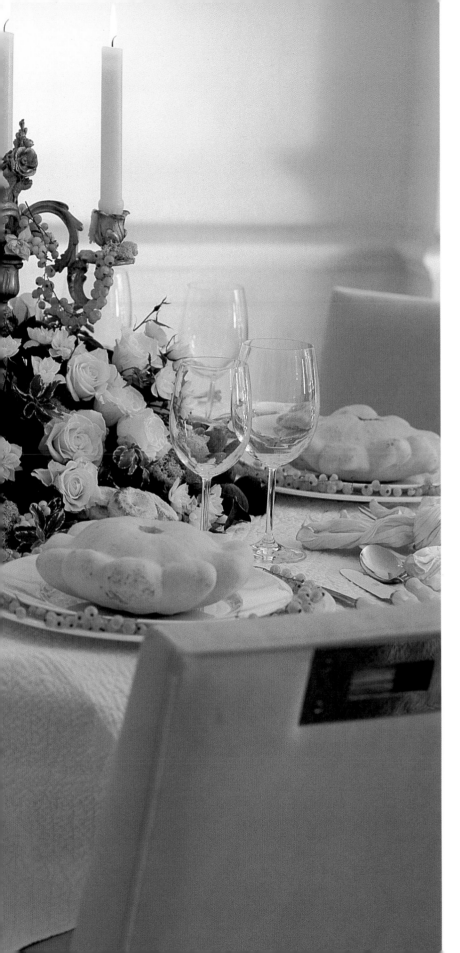

autumn
feasts

Rita Konig, daughter of the British interior

designer and my great friend, Nina Campbell,

designed and laid this wonderful table in her

London apartment to celebrate Thanksgiving

with some American friends. Her use of all the

shades of white, accented with gold, results in a

totally different approach from the usual russet

autumn colours. Yet it still evokes a feeling of

warmth and abundance, which is what

Thanksgiving is all about.

The centrepiece is a gilt rococo candelabra,

hung with sprays of white currants like strings of

beads, and surrounded with white roses and rich

greenery. The place settings were decorated with a

ring of white currants and white custard squash.

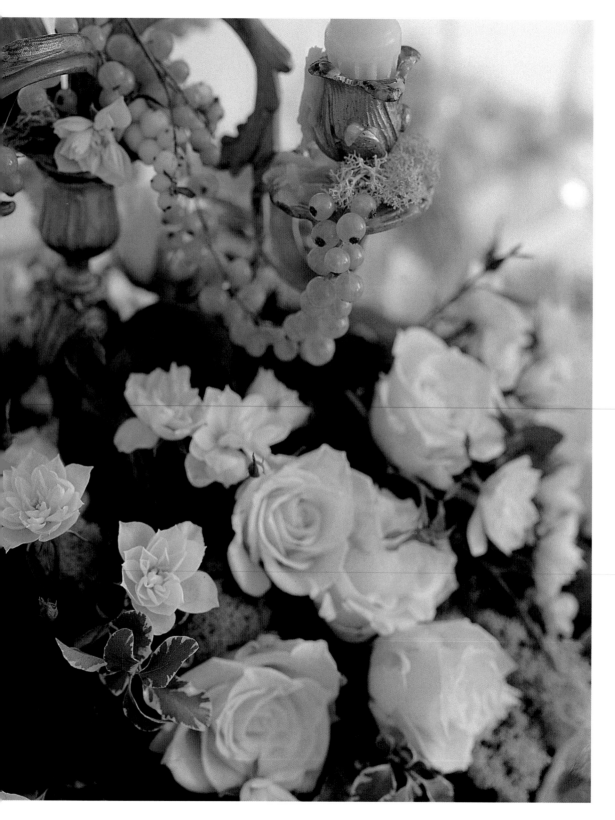

left The floral centrepiece
was built around a gilded
candelabra. The flowers
were arranged by Rob
Honey, London floral
designer extraordinaire.

right The tablecloth is, in fact, a white quilted bedspread that I found in Nina Campbell's shop in London's Walton Street – quilts make wonderful cloths for round tables. The bamboo cutlery came from Nina's shop too, as did the beautiful pleated napkins by Ann Gish.

left White currants
trail from a small
white porcelain pot.

right The elegant glasses
and the white dinner
plates are from the London
shops John Jenkins and
Thomas Goode,
respectively. I always think
food looks particularly
appetizing served on a
large, simple white plate.

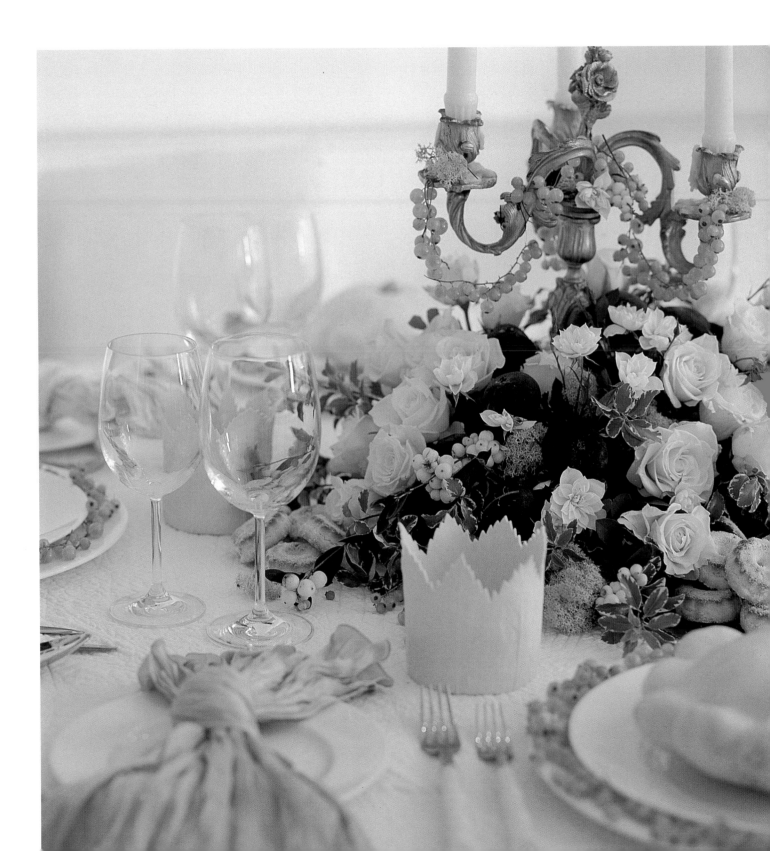

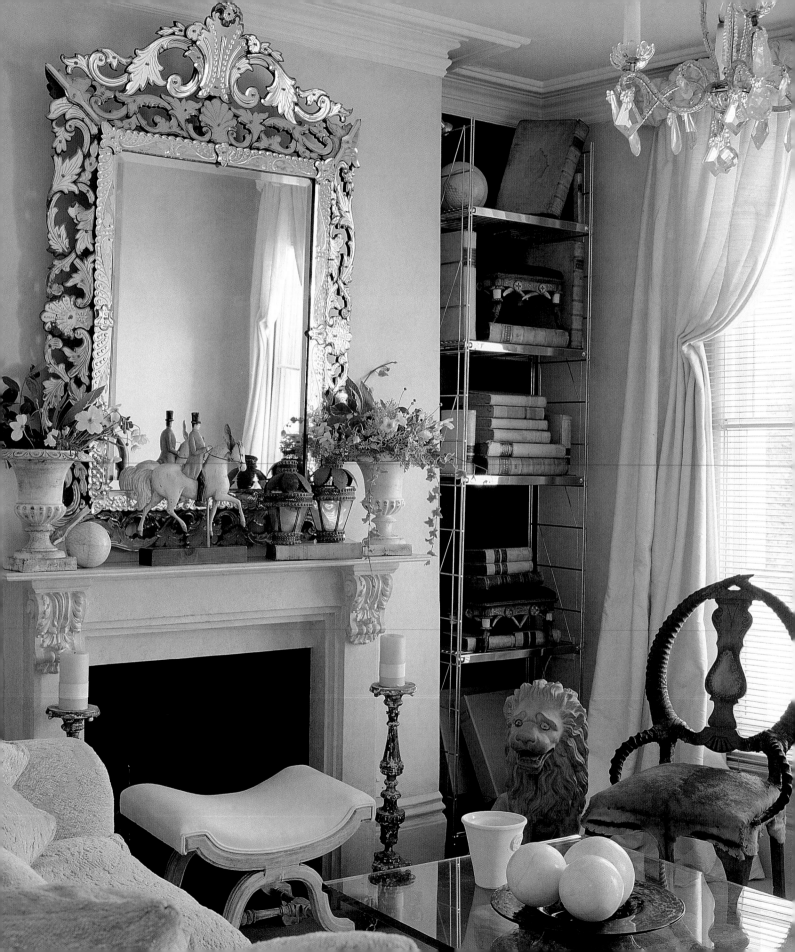

autumn interiors

This is the time of year when we turn in upon ourselves. Nights are getting longer, curtains are drawn, and doors are closed against the encroaching darkness. We want our autumn interiors to sparkle and warm us from the outside in. It is time to surround ourselves with the comfort of beautiful things and rich warmth. The white spectrum can provide all this and more, with textured fabrics, glittering surfaces, and stylish comfort.

I think Louise Bradley's drawing room, shown here, is the epitome of exciting white. Louise is a well-known and extremely talented interior designer whose treasure-trove shop is next-door to my gallery in London's Walton Street. I had long admired her ever-changing windows, which show how stunning whites and creams can be when teamed up in endless combinations with gold, silver, and glass. Her shop is always filled with things I really want, and so I was delighted when she agreed to let us trample through and photograph her home for this book.

Louise's apartment is the perfect small urban space. It is serene, quiet, and stylishly efficient, with a place for everything. It is somewhere to feel calm, safe, and cosseted, yet is in the very heart of London. What she has done is to make a small space roomy, warm, and elegant by using a mixture of luxurious textures ranging from Venetian glass mirrors to furs, velvets, and silks.

left In Louise Bradley's drawing room, the soft furnishings are an eclectic mixture of creamy fabrics with dramatically different textures. The room is decorated with white objects and glass, such as Venetian glass mirrors and lanterns, and cream fish-skin spheres. A stone lion, a crystal chandelier, and white flowers in cream-coloured urns add to the glamour.

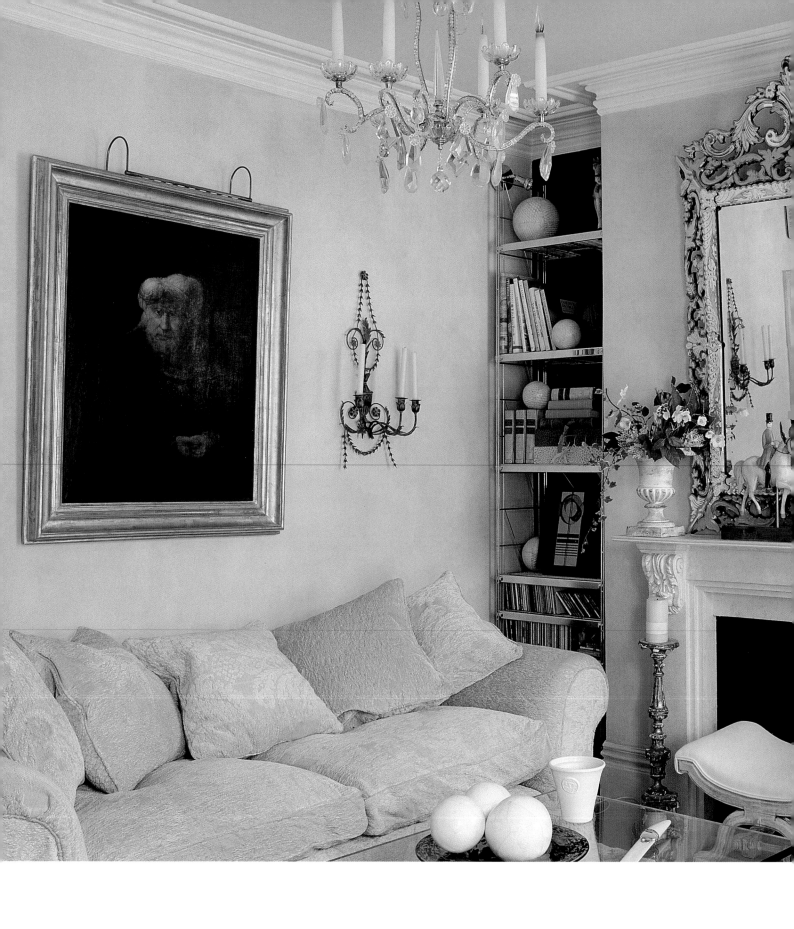

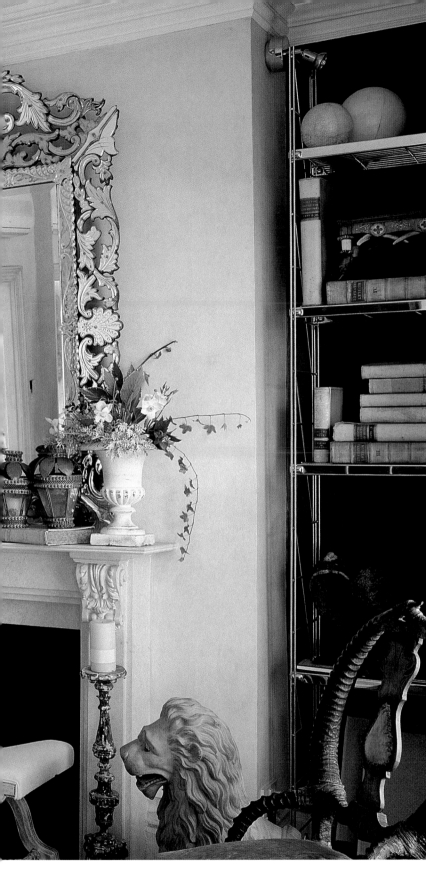

Unifying it with a white
scheme makes Louise's
small drawing room appear
larger. Although it is
crowded with lovely pieces
of furniture, one never feels
hemmed in. A low glass
table is always a good idea
in a small room, as it takes
up no visual space and
yet you can always put
something down on it.

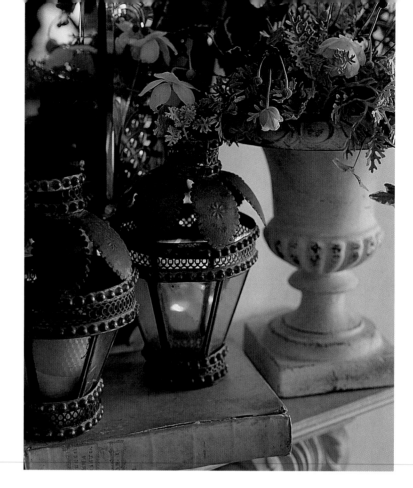

right Two antique glass
and metal lanterns sit on
top of a vellum-bound book
on Louise's mantelpiece.

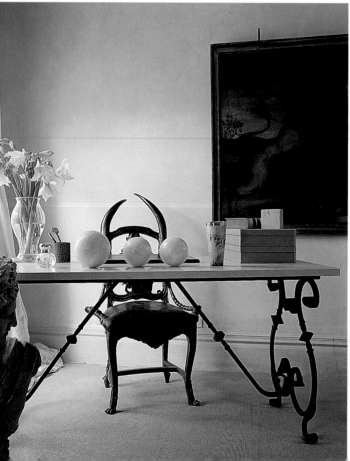

left This is Louise's work
area, which benefits from
a good source of natural
light. Her work table is a
limestone butcher's table
and her chair an antique
curiosity made from
animal horns.

right These mother-of-pearl
and silver spoons come
from Louise's shop. I love
adding them to table
settings, as even a touch
of this kind of translucent
beauty makes any table
look luxurious.

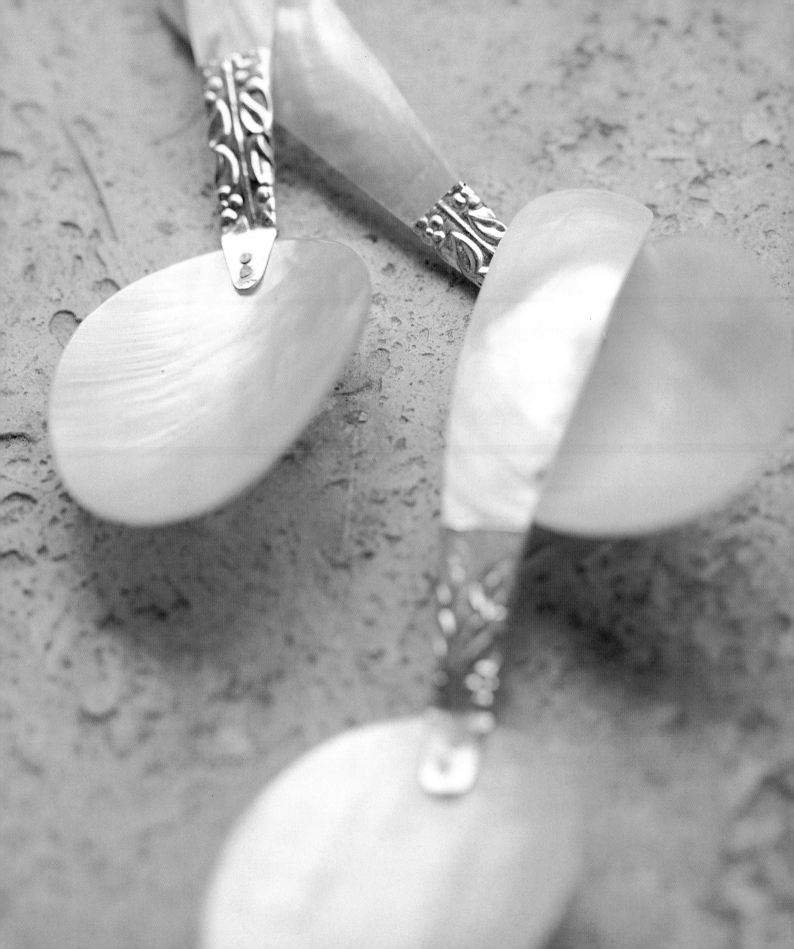

frosted
beauty

The crystalline shimmer of frosted white on

the decorative metalwork leaves (pictured

right) make me feel like this area of Louise

Bradley's shop has been frozen in time. With

the starker whites of the bust and ironwork

chair, there's almost a fairytale look about

this setting that unifies the space. Marble,

white-limed wood and painted iron on a

pale stone floor create a subtle interplay of

crisp whites and textures that boast

unobtainable beauty.

right A selection of antique white limed (pickled) furniture surrounds a plaster column and a marble bust. The great thing about white is that it transcends periods and styles, so the antique and the modern can live happily side by side.

right Beautiful pieces of antique furniture on the creamy stone-flagged floor of Louise Bradley's shop in Walton Street, London.

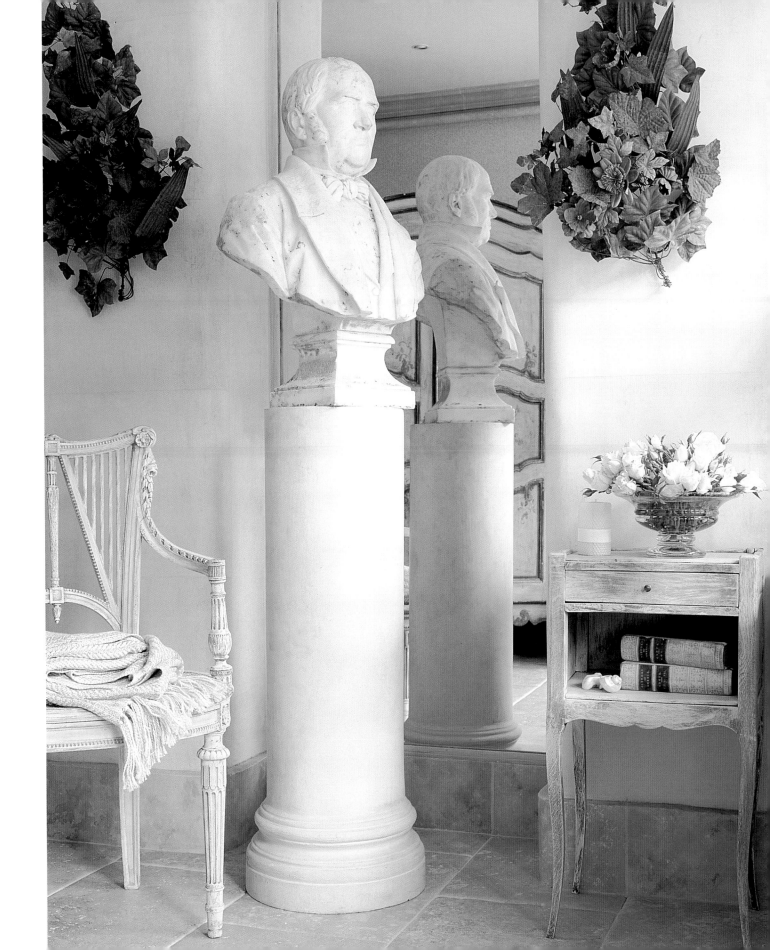

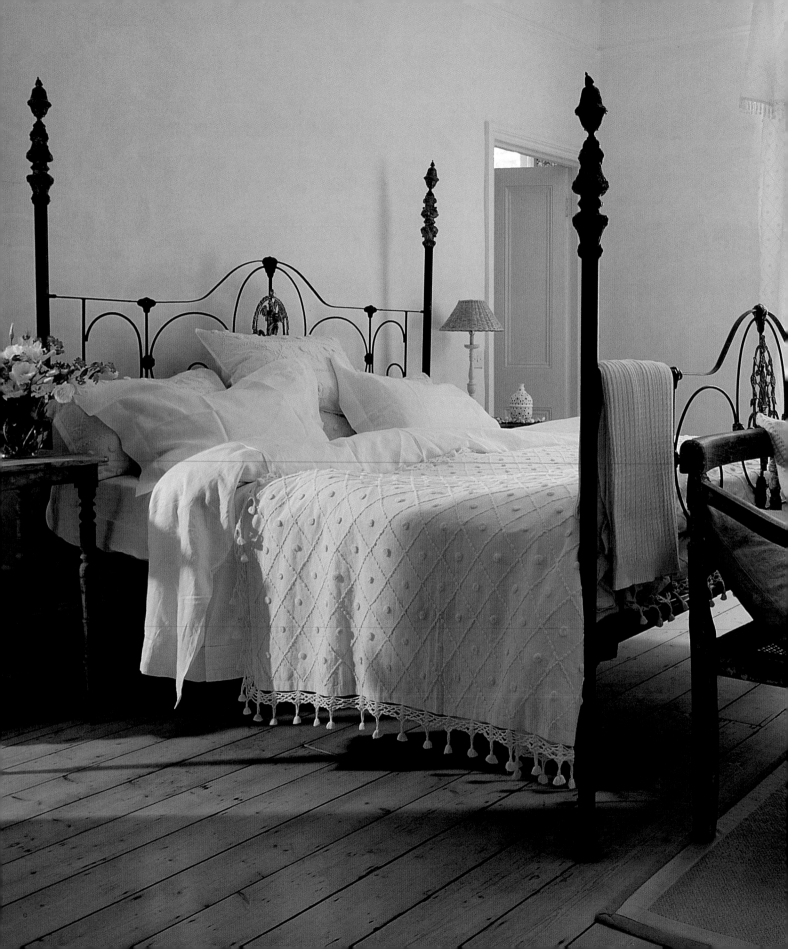

white
comfort

What do you want in a white country

bedroom when it isn't summer anymore?

The answer, once again, is texture. In this

bedroom, which was seen in its spring

dressing on pages 36–9, the end of summer

is signalled by the appearance of the

beautiful fringed and embroidered bed

throw from the London fabric shop Chelsea

Textiles, which matches the white

embroidered curtains and valance.

Pillows and warm cashmere throws are

piled on the plain wooden bench at the

bottom of the bed in case of a cold snap,

and a simple woollen rug takes the chill

off the floorboards.

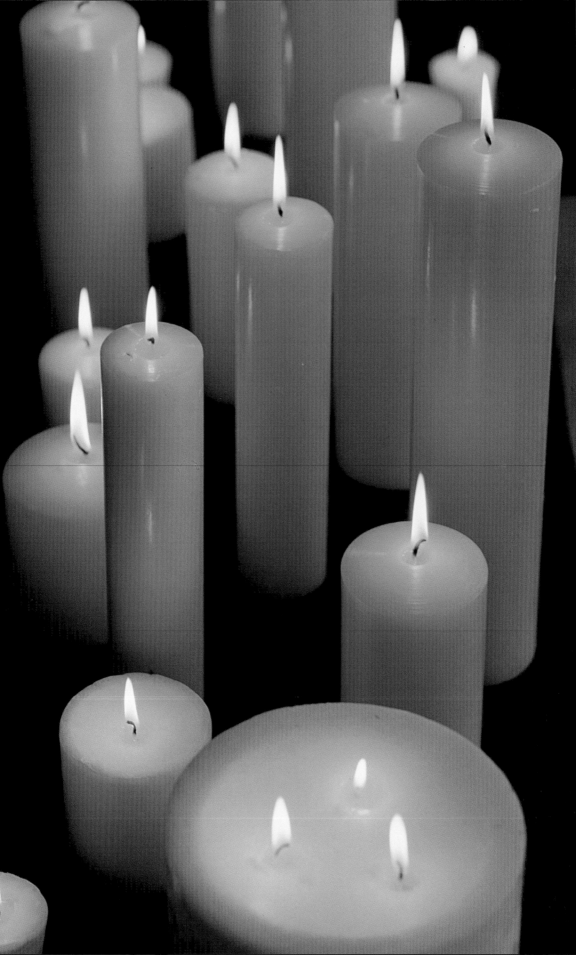

Winter

There are few things whiter than new-fallen snow. It looks so white because it only absorbs about five percent of light and blindingly reflects back the other ninety-five. Imagine a white, white world outside, or at least a landscape tinged with hoar-frost: the aim of winter whites is to help us relax in a warm and calming environment, providing a soft, textured contrast to the hard-edged realities of cold and frost and frozen puddles.

This is the season for mother-of-pearl catching the light from the fire, for thick white cable-knit sweaters and white cashmere scarves, for soft white fur and creamy white leather.

In the kitchen the rich, dark Christmas cake mixture is covered with white frosting, slices of stollen are dusted with icing sugar, and silver dishes are piled high with white iced gingerbread cookies and marzipan treats.

In the living room, luxurious white velvets and textured silks provide a touch of luxury, while pale tweeds and thick, undyed woollen throws keep in the warmth. Gleaming glasses, generously sized white china platters, and sparkling silver decorate the table, while shiny decorative touches remind one of the sharp frosts outside. The smooth, enigmatic spheres of ostrich eggs or shelves full of interesting parchment-covered books are all possible elements here.

In the bedroom, beds are buried under huge fluffy duvets or cozy white quilts like the traditional French Provençal *boutis* — hand-quilted with a fine cord inserted between the two layers to give added depth to the elaborate pattern. It's worth remembering, too, that thick white rugs, piles of inviting pillows, and low-level lighting all give a winter bedroom a necessary dose of coziness. In the bathroom, glass containers are filled to the brim with pearly white soaps, and a stack of rough white towels promises to stimulate the circulation after a steaming hot bath.

White flowers look wonderful in winter. Armfuls of lilies or a regiment of little pots filled with alpine roses make any room look cool and elegant and ready for a glamorous party. As for winter accent colours, try the sparkle of silver and the deep, dark green of evergreen foliage that is so essential to the winter palette, and indeed to all winter celebrations.

white

ice

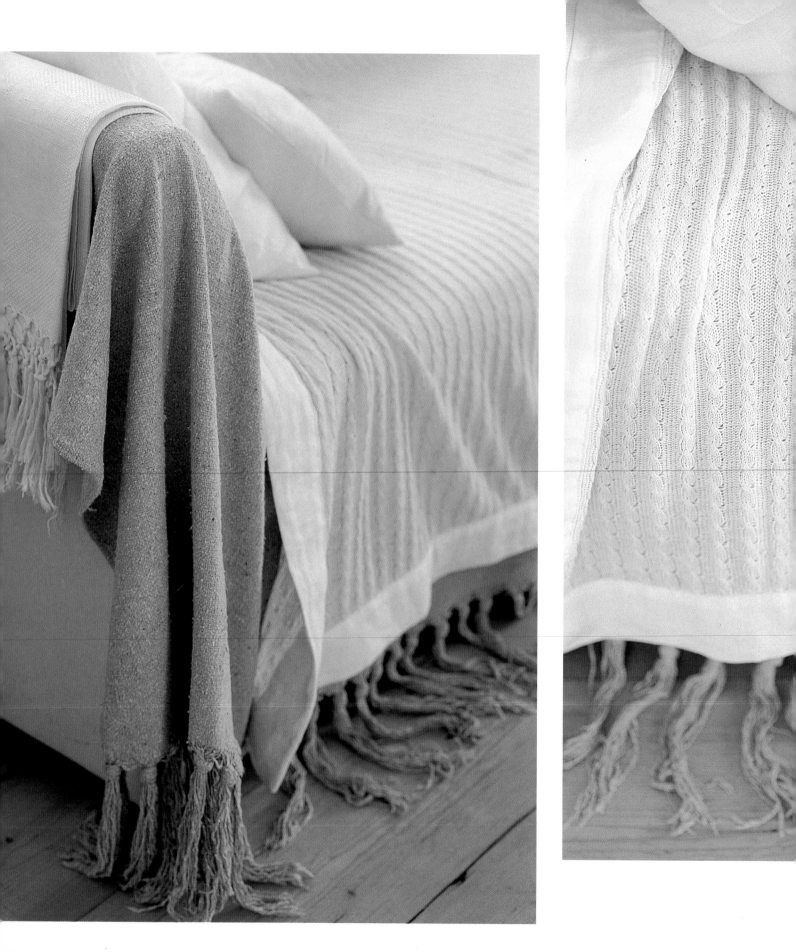

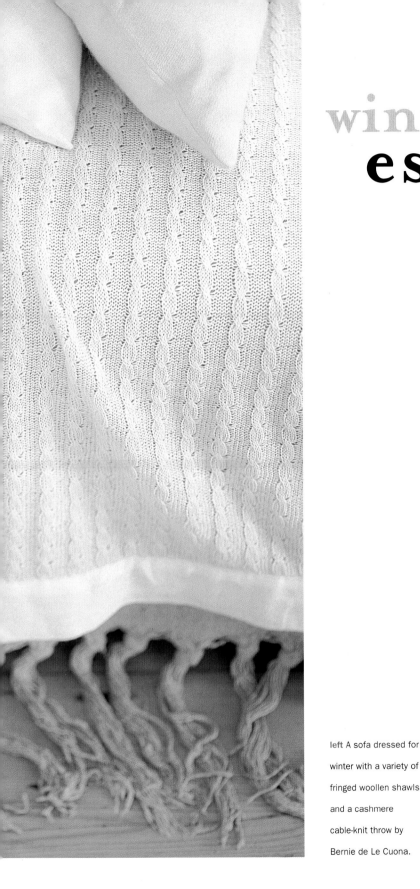

winter essentials

For me, the essence of winter decorating can be summed up in one word: warmth. White warmth is no less cozy than being wrapped in a multicoloured blanket.

Winter is the time to add both texture and substance to a room. You need to find whites that are the colour of rich cream and fabrics that have been quilted, padded, embroidered, or knitted.

It is amazing what you can do with a sofa throw, for instance. If your sofa has a white, washable slipcover, you can pile it with fresh-looking pillows in spring, leave it bare in summer, throw on a little texture in autumn, and bring out the thick warm wool for winter.

left A sofa dressed for winter with a variety of fringed woollen shawls and a cashmere cable-knit throw by Bernie de Le Cuona.

below A silver-plated basket filled with large, crisp table napkins – all dating from the nineteenth century. The glass is Baccarat crystal, and the pistol-shaped handles of the fruit knives are in mother-of-pearl.

right Striped white and clear glass, called latticinio glass, was made in Italy, France and the North of England in the 1700s and 1800s. The latticinio glass hat is English. These hats come in all colours and are very collectible.

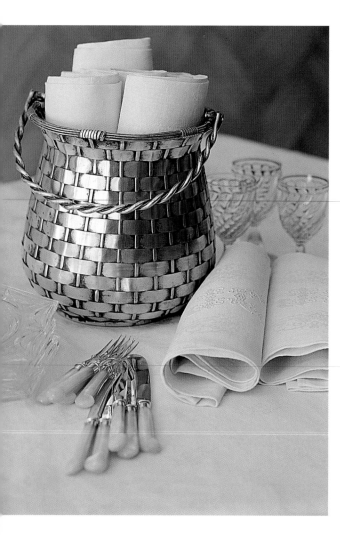

centre right Add sparkle to the table with napkin rings and placemats made from silver wire.

overleaf Nineteenth- and early twentieth-century napkins are always extravagantly large. Made from a fabulous, almost indestructible linen that feels marvellous, they even seem to launder better than modern linen. Plain ones can be bought for a fairly modest outlay, but watch for ones with hand-embroidered initials – preferably your own, of course!

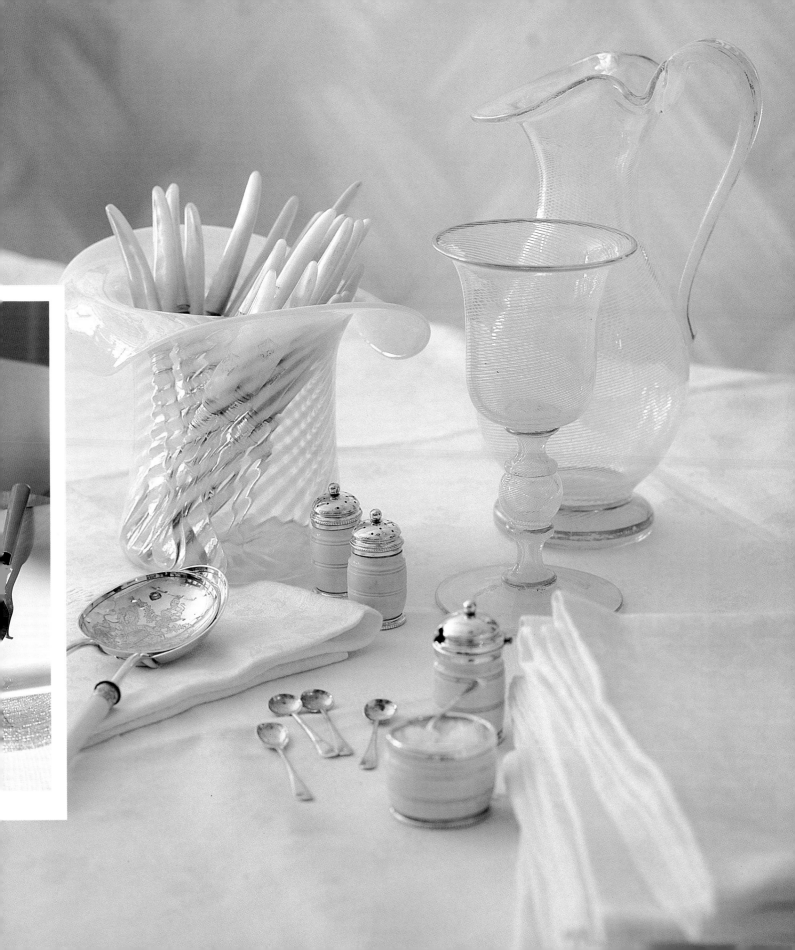

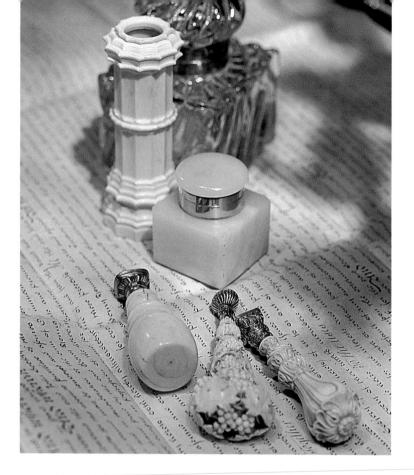

left A vellum deed of property dating from the 1800s. Deeds like these are used by antique dealers and decorators for many purposes, as vellum is such an attractive and durable material. In my gallery I often incorporate them into my frames. On the document is a collection of ivory seals, an ivory quill holder and a milk-glass inkwell.

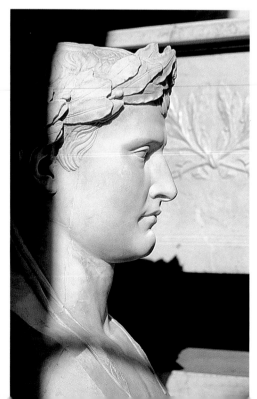

left A nineteenth-century marble bust of a laurel-wreathed poet. Classical busts fit into any decorative scheme, traditional or modern. As with all things white, they fit in especially well, as they do not leap to the eye or take up visual space.

right These large lavender bags are made from remnants of antique linen trimmed with lace and hand-embroidered initials. I purchased these after we photographed them, as presents for special friends, and they are making my gift drawer smell amazing. You can get some idea of the scale from the large hat-box that they are leaning against.

overleaf A shelf in a bookcase in my drawing room is framed by a Neo-Gothic arched pediment in a wondrous shade of Scandinavian grey-white, the result of age rather than a deliberate choice of paint. Against this backdrop, I have stacked vellum books, odd droplets of glass from long-forgotten chandeliers and candelabra, a pretty milk-glass tazza, and a shimmering array of nineteenth-century vases and champagne glasses.

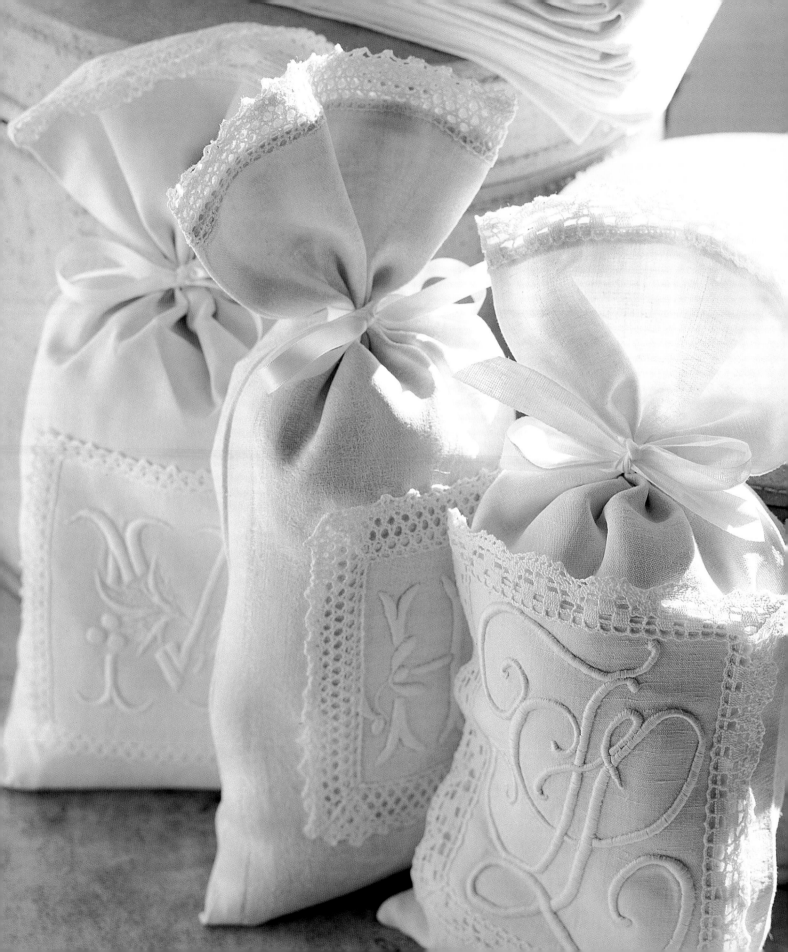

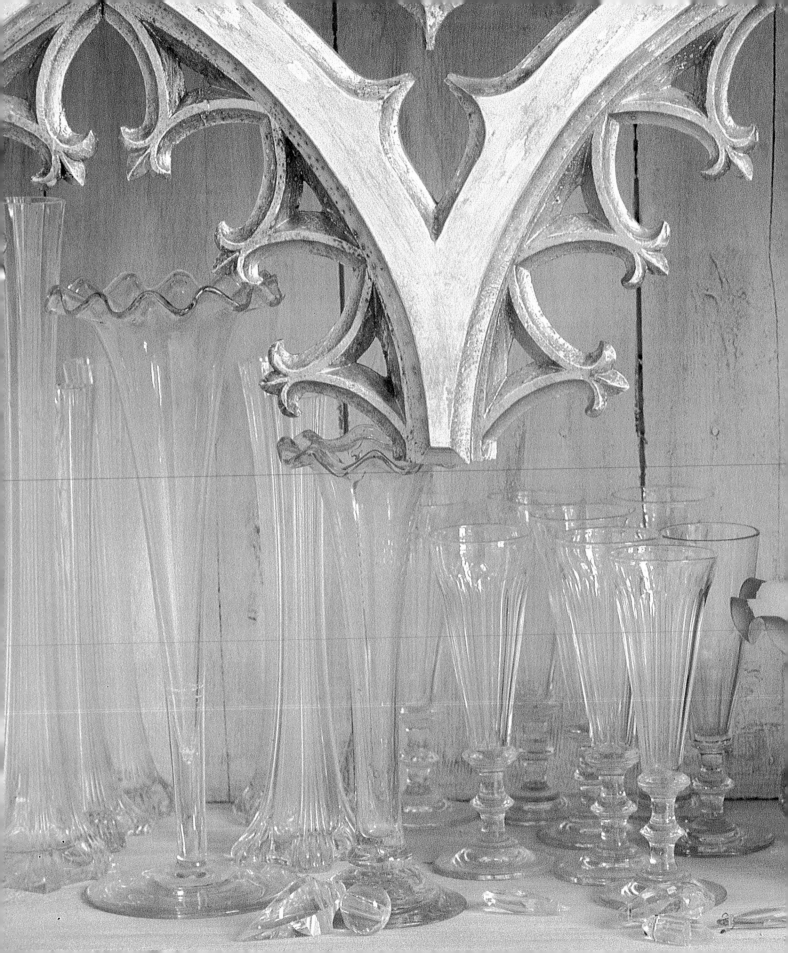

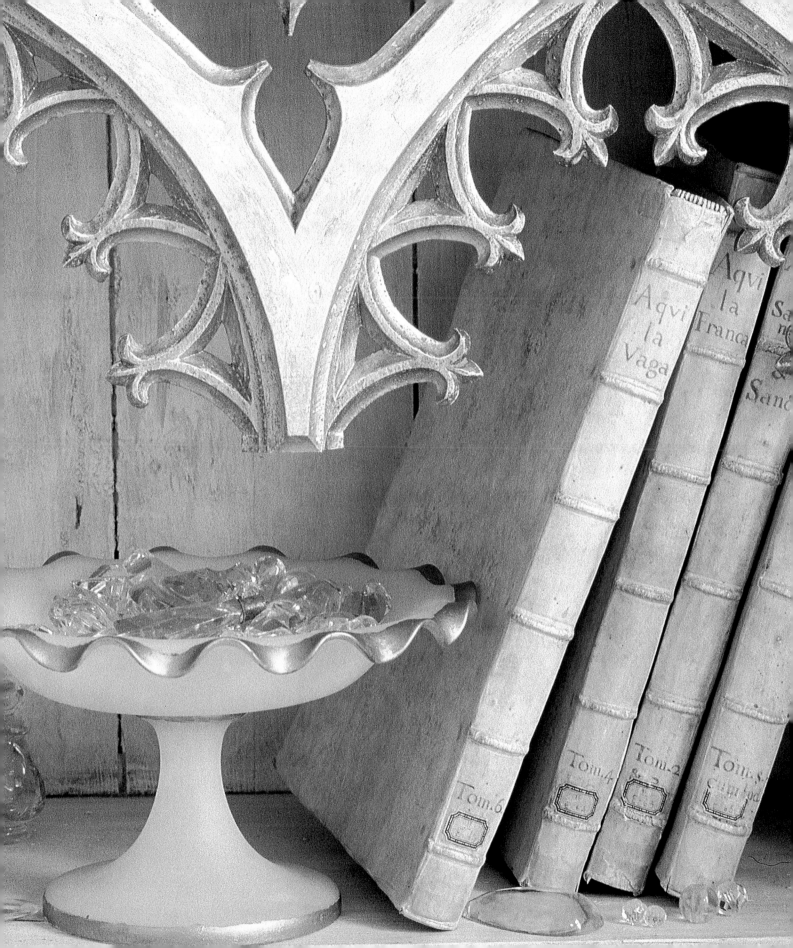

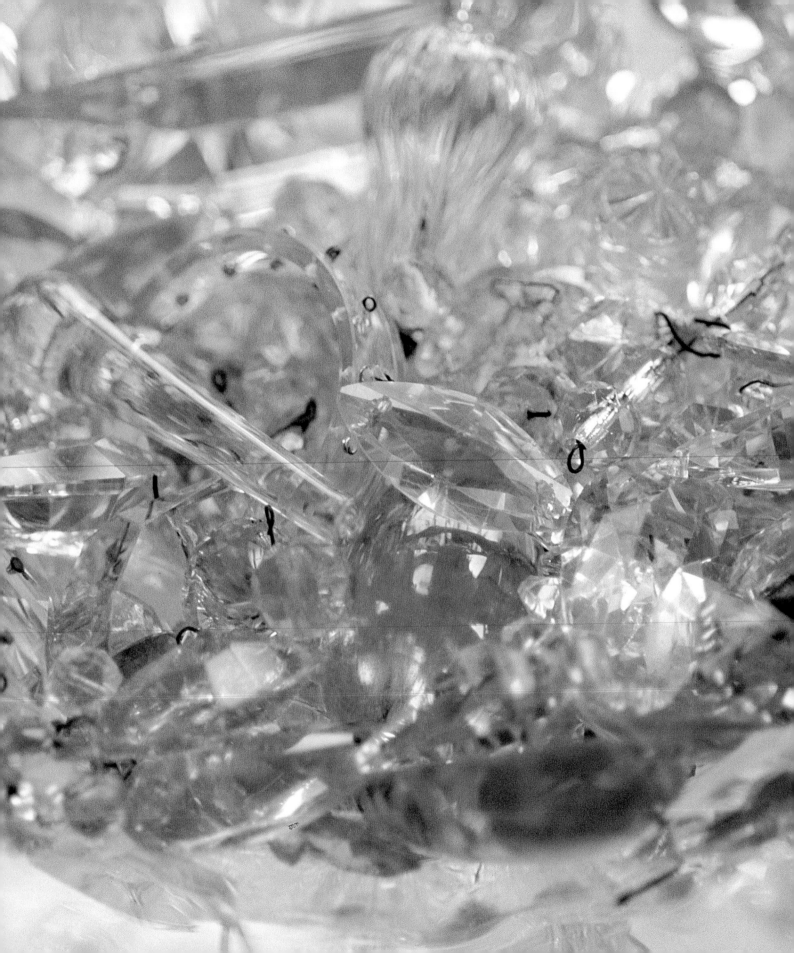

winter
sparkle

This is what winter needs – things that gleam and sparkle by firelight, by candlelight, and also by the light of day. I love cut glass, and one way that I like to use it in abundance is to collect droplets from old chandeliers. In the main picture, a generous handful of crystal droplets (which must be clean or they won't sparkle) have been massed together in a glass dish. The nineteenth-century English bon-bon dish in the smaller picture is filled with shells, which look like a million dollars but cost practically nothing.

winter
buds

Anemones are appealing flowers and full of

character. They brighten up the winter months

considerably. Here, I've put them one by one

into a collection of bud or corsage vases that I

have collected over the years. I mainly find

these miniature vases at Kate Bannister's shop

in London's Camden Passage. They can be

used in so many different ways, such as marking

individual place settings or lined up on a

mantelpiece or a shelf. I like the look of

unmatched vases all containing the same

flowers, albeit with different stem lengths.

The paintings, by Galley (see page 10),

depict more of my favourite winter flowers –

snowdrops and snowberries.

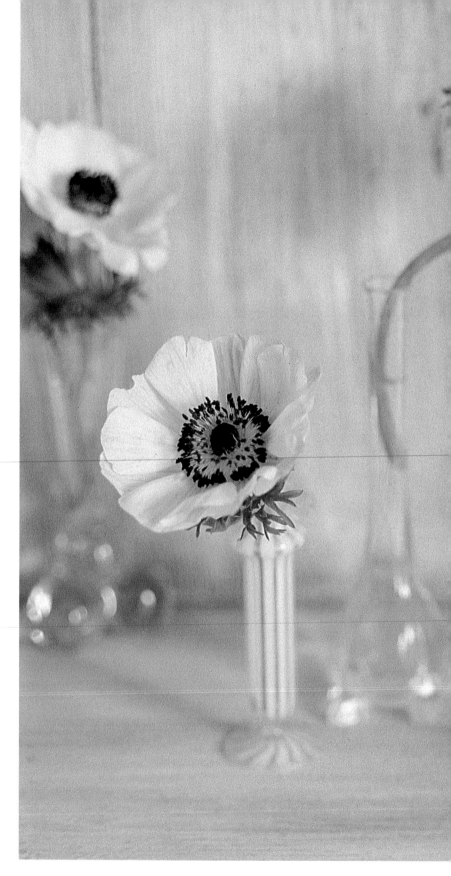

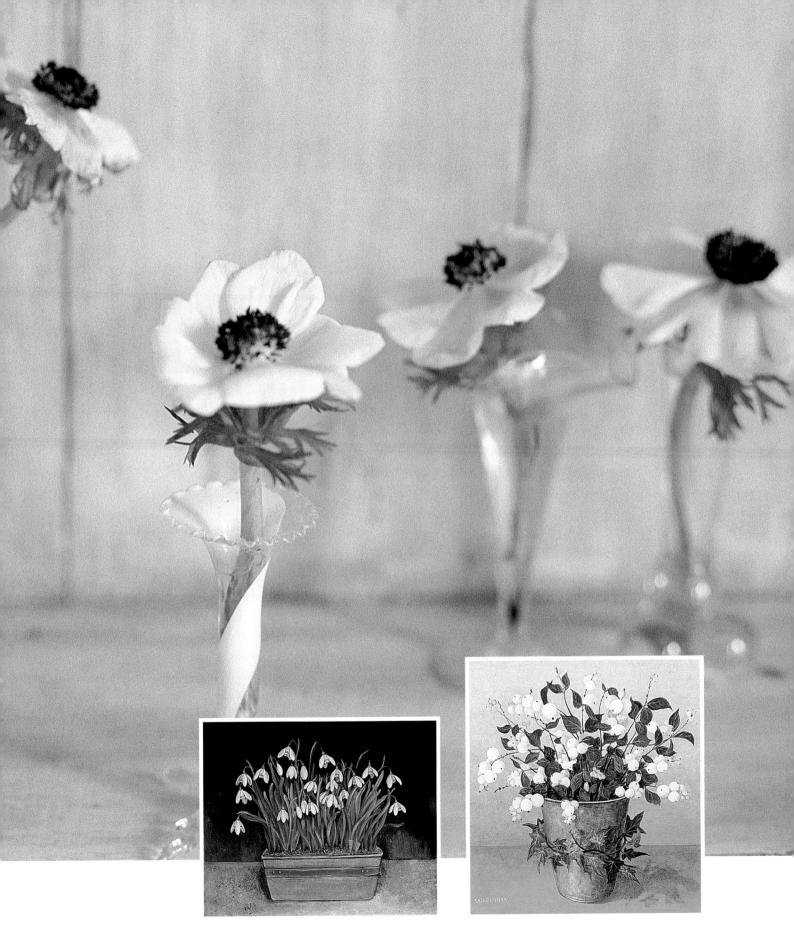

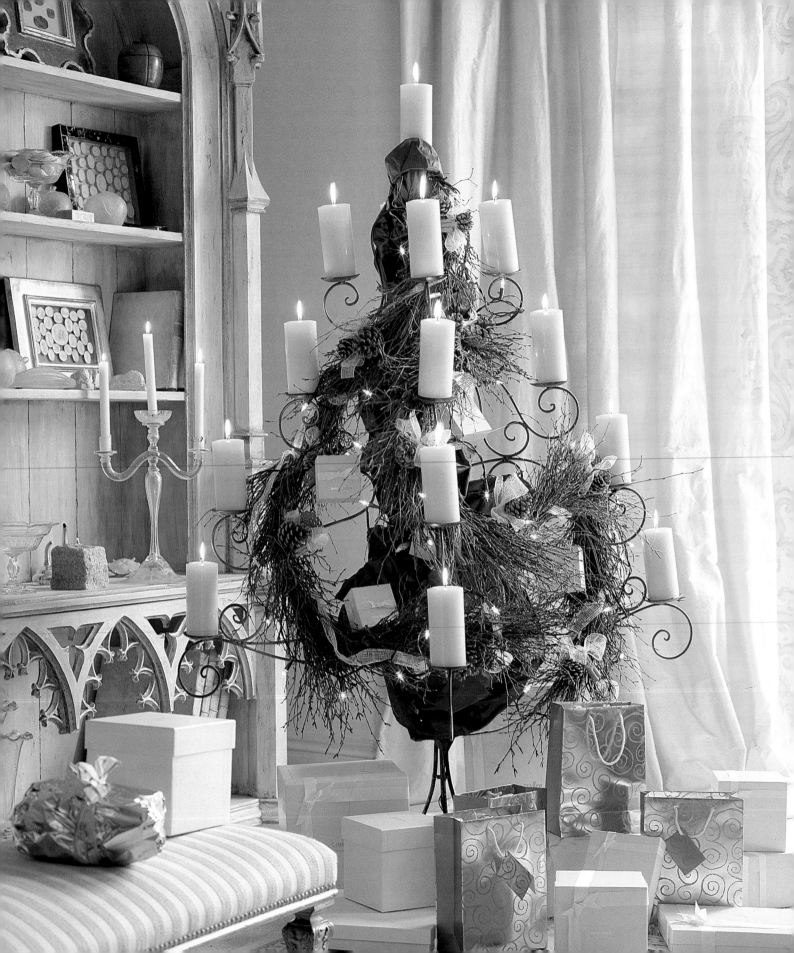

winter celebrations

A lot of feasting takes place during the winter, so houses need to be decorated, tablecloths starched and ironed, silver and glass polished, tables laid, and guest rooms aired and dusted for friends and relatives.

Winter solstice traditions all over Europe and North America call for evergreen trees and boughs to be brought into the home as a way of celebrating this time of death and renewal. The dark greens of evergreen trees and shrubs smell like winter and look glorious hanging in festive swags around the walls of a room. When combining white with greenery, I would take my cue from the light green mistletoe rather than the dark green holly bush.

Candles are symbolic in many faiths and festivals, such as Chanukah; a lone candle signified peace in many millennium services. A hallmark of winter celebrations, candles can be used *en masse* in interiors — I like to use creamy beeswax candles rather than startlingly white ones; although they are more expensive, their light is incomparably soft.

left A Christmas tree by Louise Bradley. This no-colour tree was designed by Louise for my drawing room – a room of great peace and serenity, which is painted, curtained, and furnished in five shades of white with gold accents. In design terms, the Christmas tree is perfect for the room, but at the same time it has a uniquely festive feeling.

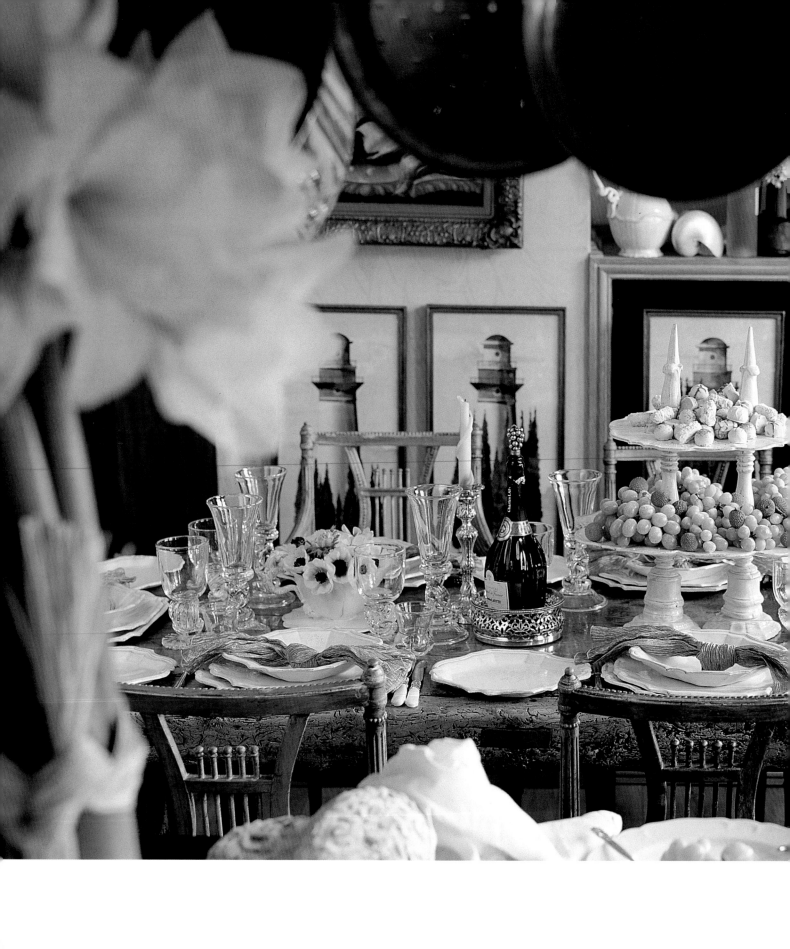

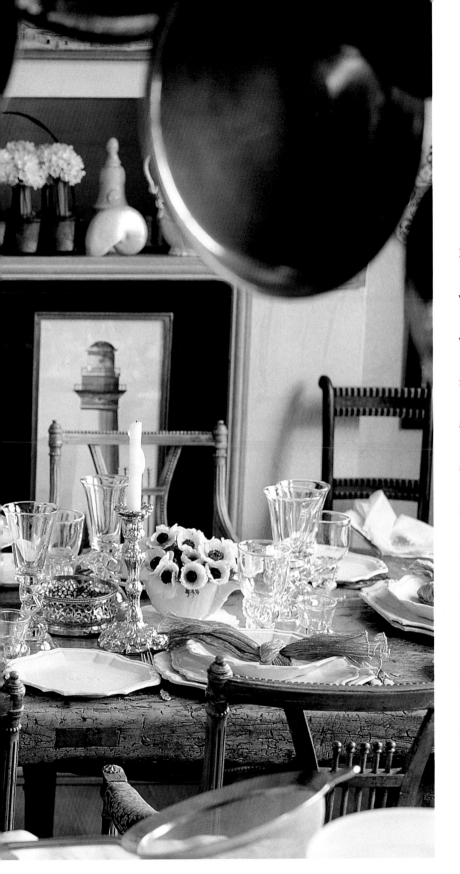

white
christmas

I was certainly dreaming of a white Christmas when I was inspired to create this glistening white setting. Like most families, I usually go for a more traditional combination of reds and golds, but I wanted to experiment and try something new and fresh that kept the festive feel. The china is from the Loire region of France, where I was lucky enough to find a family concern that still makes faience in the traditional way. The shapes are irresistibly eccentric, and the china combines well with the crystal and other glassware. Bundles of white amaryllis, tied with raffia, and a pair of sauceboats crammed with white anemones, make refreshingly simple Christmas flowers.

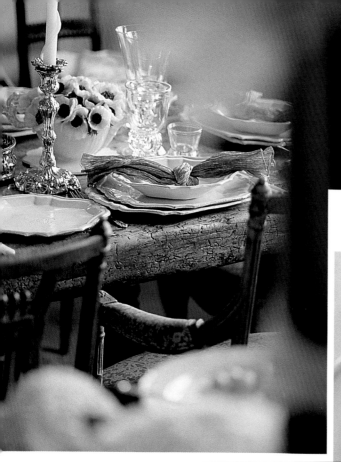

right These hand-blown crystal goblets by Antony Stern are my passion – I have been collecting them for over a decade. Their luminosity is a tribute to Stern's masterly technique. My favourites are the small "champagne-cork" glasses for after-dinner digestifs.

above A mixture of pale tones and varied textures creates a subtle harmony at the Christmas table. The creamy colours of the anemones and candles gently contrast with the pure white china, bronze napkins, and wooden table, while the rich variety of textures adds depth and interest.

right In the window, a nineteenth-century lace curtain provides a soft background to a Venetian candelabra and a pearly nautilus shell, building up layers of textures.

right I topped each faience plate with a napkin made from a shimmering bronze, Fortuny-like pleated fabric which I knotted and pushed through faience napkin rings made specially for me.

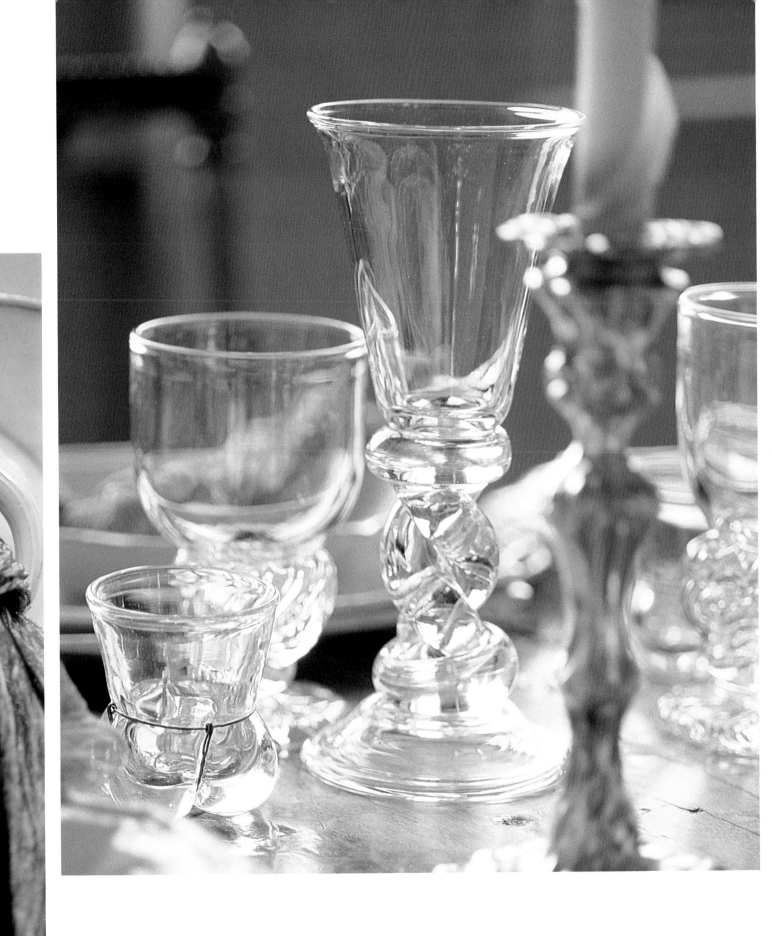

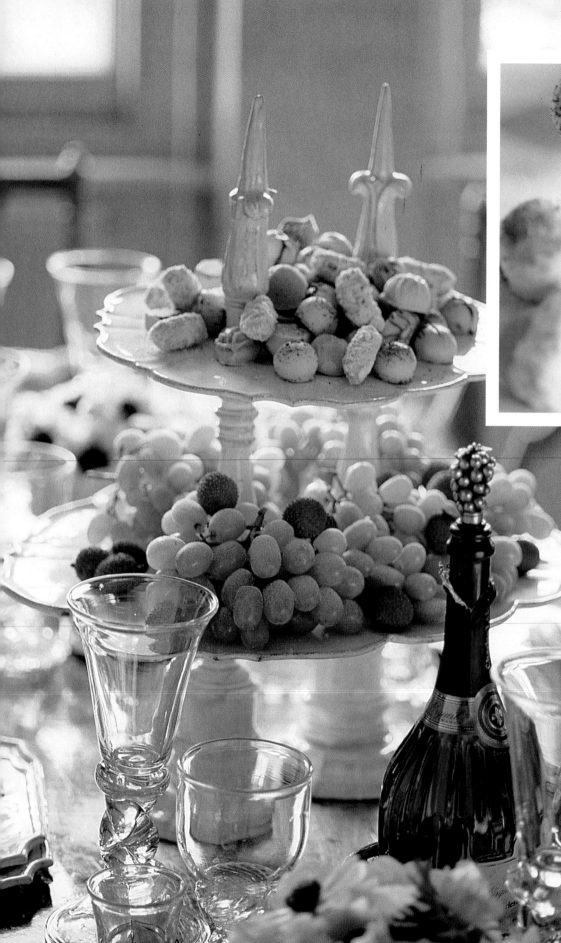

left and above An elegant
two-tiered fruit platter
forms the centrepiece at
my Christmas table. I piled
grapes on the bottom tier,
dusted them with sugar,
and dotted a few lychees
around for a bit of contrast
and texture. The top layer I
filled with creamy-coloured
white-chocolate truffles.
I have laid more glamorous
tables than I care to
remember, but this is the
one I love most.

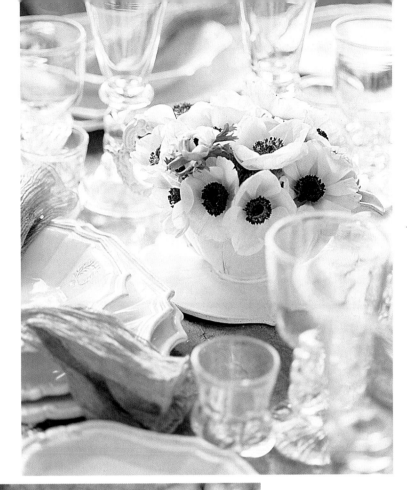

right The faience china is an elegant shade of white with a perfect glaze.

below This home-baked loaf – deliciously nutty – is served on a late nineteenth-century bread board set into a silver-plated holder.

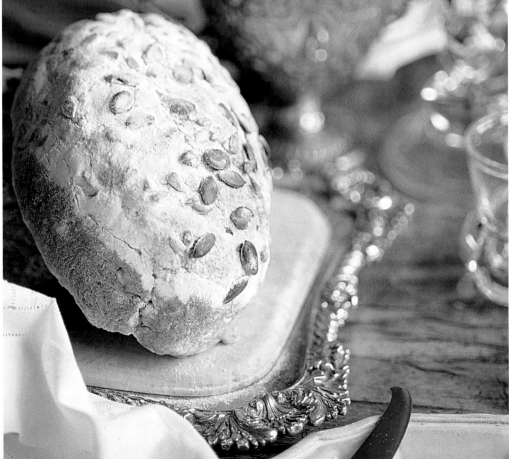

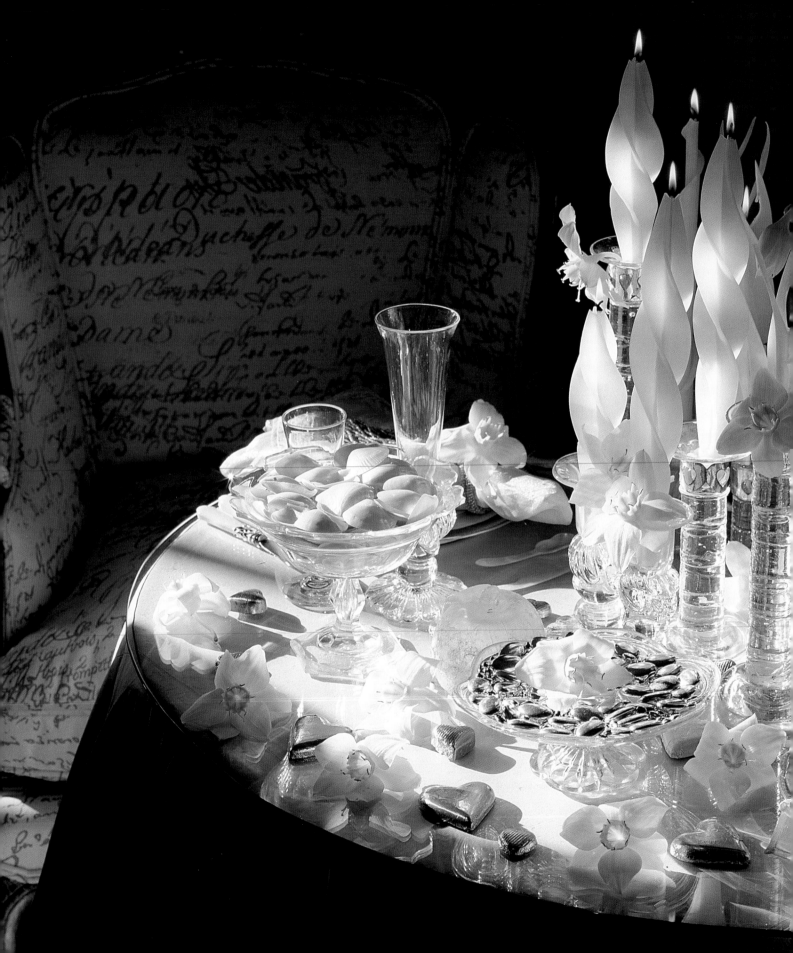

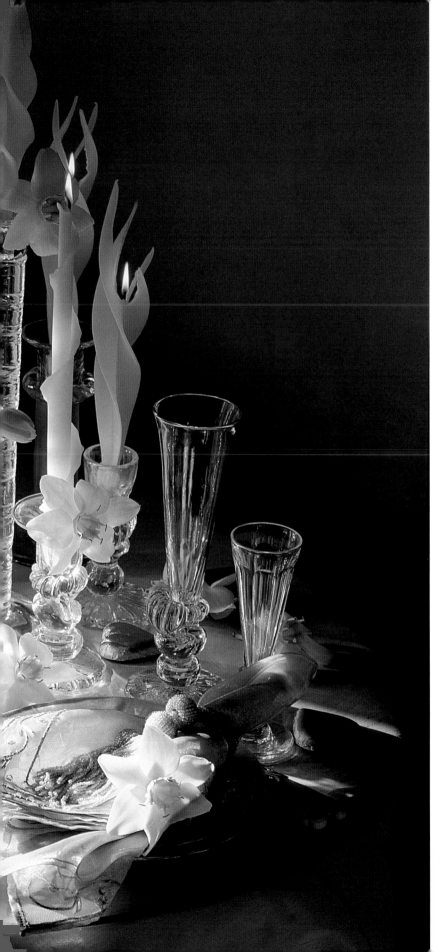

winter
romance

I laid this table as a perfect dinner-for-two: to

celebrate an anniversary or an engagement or

perhaps a Valentine's Day dinner at home.

Everything in the picture was already in the

house – it was just a matter of putting all the

elements together. I have to admit that I

collect glass candlesticks, so I had plenty to

choose from. Do not go for matching pairs, it

spoils the look of romance.

 I put a floor-length cream silk cloth on the

table, covered with a glass top for extra sparkle.

The French eighteenth-century chair in the

background is upholstered in a fabric by

Carolyn Quatermaine, incorporating subtle

gold writing on creamy-white cotton duck.

right The cloudy glass apple comes from a set of glass fruits made in the 1920s. Heads of white Epiphany lilies and gold foil-wrapped chocolate hearts are scattered on the table. Dragées – silver sugared almonds – are heaped on a glass plate, and shells are piled into a bon-bon dish. It's all sparkle here.

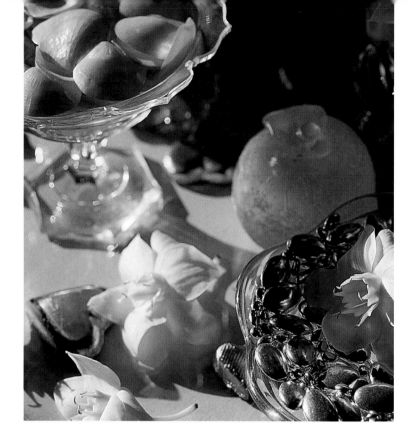

right Detail of some of the glass candlesticks and their twisted, baroque bases. All the candlesticks and glasses are by my favourite glass-maker, Antony Stern. The double-layer, hand-beaded silk table napkins (for special occasions only) are by Sethi and Sethi of New York, and the divine tasselled beaded napkin rings are by Wendy Cushing.

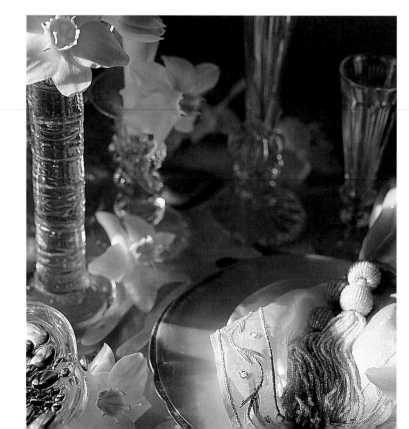

right These twisted candles are my absolute favourites of all candles. They are made in California and are available all over the United States, and sometimes from my gallery. I love the way they burn down, shielding the flame like a ballet dancer with graceful arms.

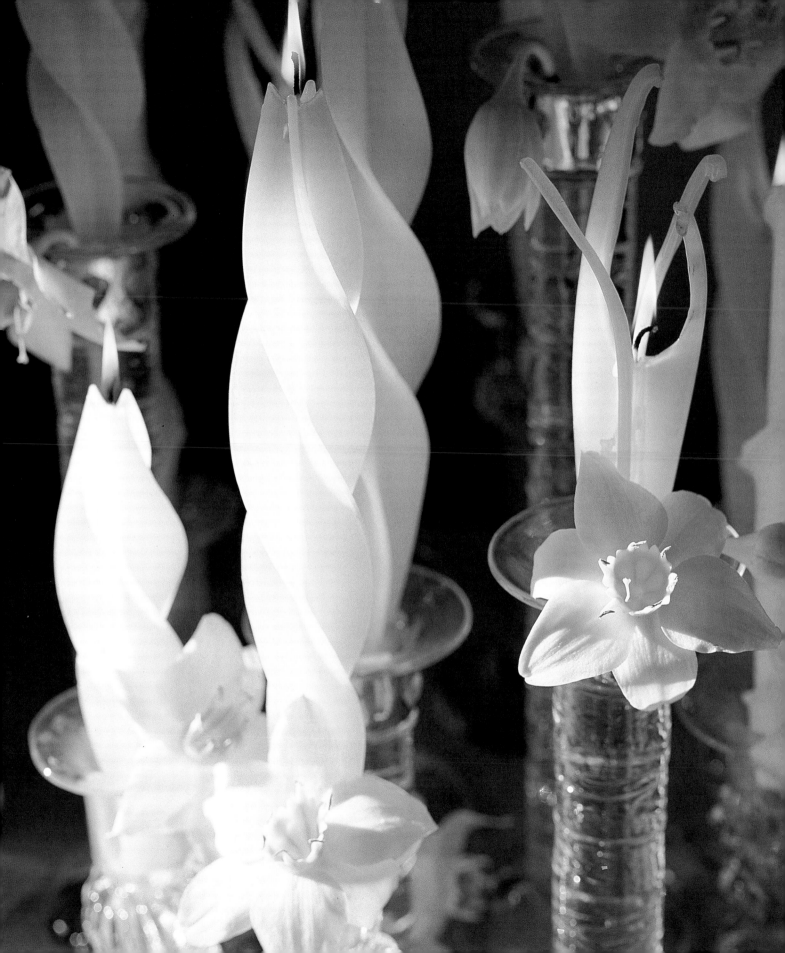

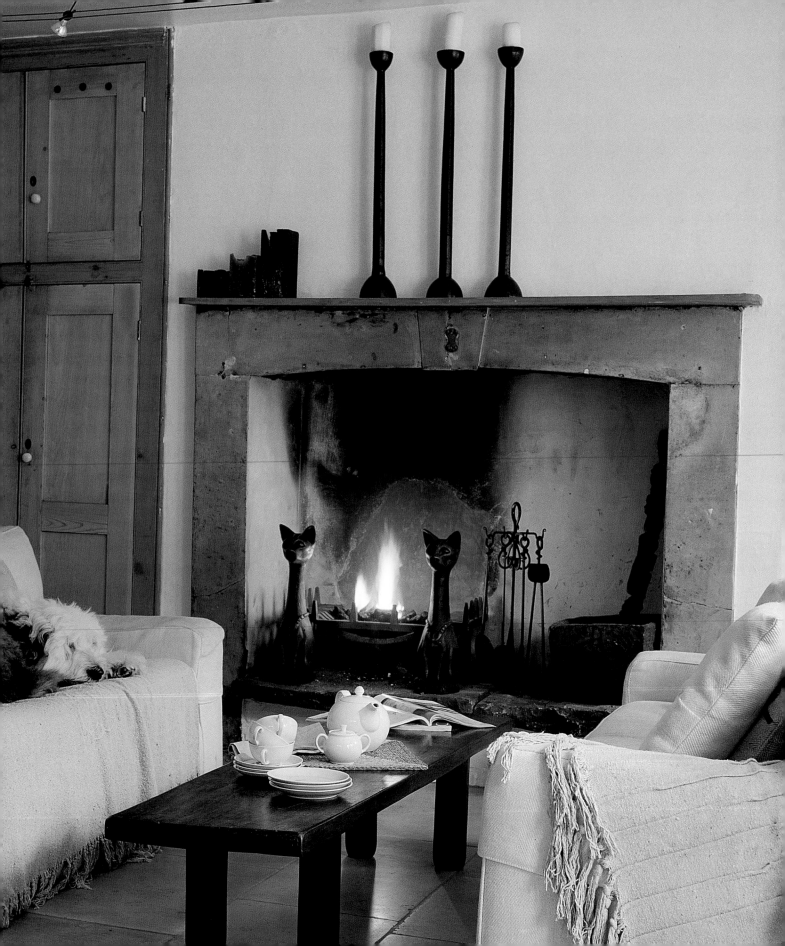

interiors winter

Imagine firelight flickering on a white wall — all the shapes and shadows leaping and gleaming. Whereas dark colours absorb light, white gives it all back to you. White transforms the scale and character of a room and also brings out all the different textures, reinforcing tactile impressions.

Winter is a time for the voluptuous white interior: padded, snug, and wrapped in thick, comfortable fabrics. So a palette that actually forces you to notice the rib on an Indian cotton, the glow of creamy vellum, the grain of painted wood, and the patina of old marble, can only be a good thing. In addition, white is so versatile: it is a colour that suits the town house as much as the country house. White can be hard-edged, sophisticated, and urban — or lived-in, comforting, and rustic. It's as well suited to dogs and log fires as to Martinis and minimalism.

I actually think that white is quite practical. Obviously very small children with sticky hands and a brand new set of finger-paints are a bit of a threat, but if you confine such activities to a playroom or a kitchen, then white is no more vulnerable than any other colour. No surface is totally stain-resistant, so unless you want to coat your room in stainless steel and plastic, you have to accept a few cleaning bills along the way. Choose washable fabrics and slipcovers, take reasonable care, and snuggle up for winter with a heap of cozy white.

left The kitchen of designer Bernie de Le Cuona's home in Windsor, England, was once three separate rooms. This part, with the stone fireplace, comfortable sofas, Cotswold stone floor, and built-in cupboard, was once the butler's pantry. The candlesticks are from Africa, and the fire-cats from Camden Market in London.

winter
warmth

The designer Bernie de Le Cuona makes the

most wonderful throws and pillows, and

collects together objects you would never find

anywhere else.

The stunning fringed throw in the main

picture is made of the finest suede, and Bernie

also makes pillows to match. The suede looks

amazing and feels even better, bringing a real

touch of warmth and an unexpected texture to

the room in winter.

The sofas themselves are upholstered in

a very heavy, coarse German linen. The table

in the foreground of the inset picture is of

African wenge wood and the pretty white

teacups are made of bone china.

right Textures are all important to South African born designer Bernie de Le Cuona. Here, a fringed suede throw is draped over an upholstered linen sofa.

right A throw, a length of pleated tussah silk, is teamed with buttoned cushions made from the same upholstery linen.

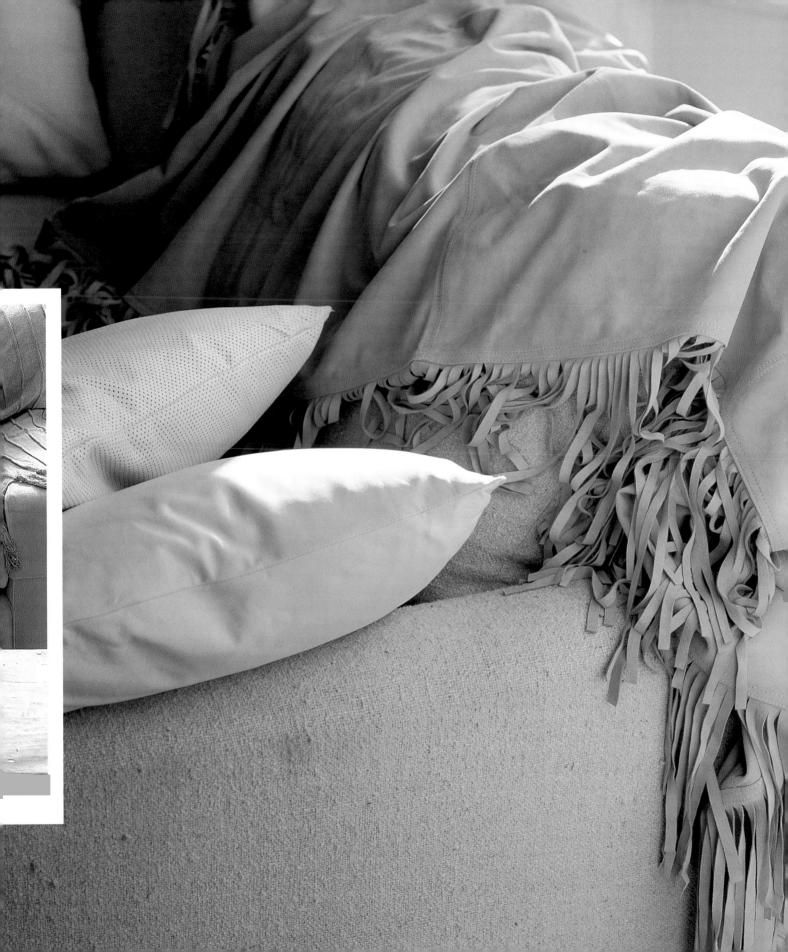

right This Roman shade is
made of heavy linen, its
lines echoing those of the
panelling all around it. The
Japanese chair in the
foreground is carved from
a single piece of wood – a
stunning sculptural piece.

above The staircase of
Bernie de Le Cuona's
home, with the shade
drawn against the wintry
chill outdoors. This
photograph demonstrates
the way in which a white
shade earns its keep all
year round. Because it
softens the light without
reducing it, summer light
feels cooler and winter
light warmer.

right On the table under
the window is a wooden
bowl filled intriguingly with
bleached animal vertebrae
collected on various
African safaris. The bowl is
set on a table which in
winter is covered with a
woollen cloth.

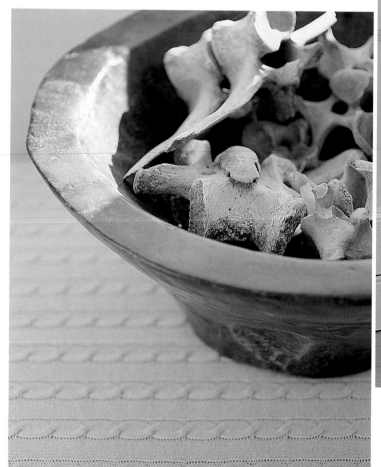

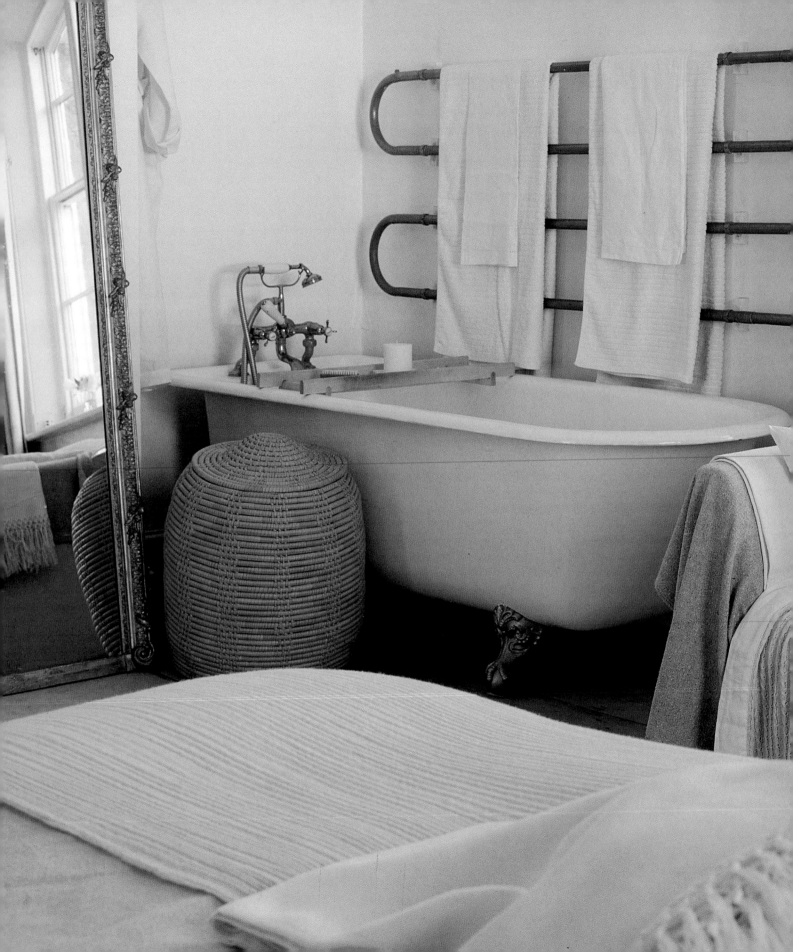

pure
comfort

This is the bedroom in Bernie de Le Cuona's home. The room is huge, and this corner was once partitioned off to make an en-suite shower room. Bernie decided to restore the proportions of the original room and invite the bath inside. It is a big, old-fashioned cast-iron bath, the kind that keeps the bath water hot. The heated towel rail was made from a continuous length of copper plumbing pipe, the laundry basket is from Africa, and the magnificent French mirror that leans casually against the wall was an antiques shop find. The sofa is handily positioned for resting after the rigours of a long soak. This is a bedroom designed to ease away the cares of the day.

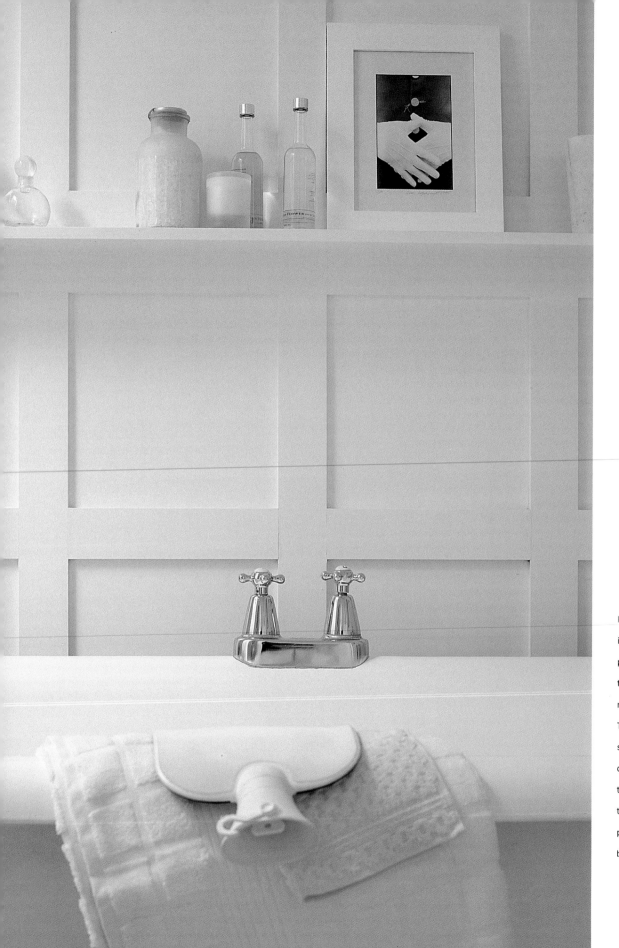

left With its roll-top cast iron bath and white painted wood-panelling, this bathroom has distinct minimalist tendencies. Touches of light gleam and shine from the glass decanters and silver-topped bottles prevent the beautiful, calm, pared-down look from becoming too austere.

right A simple wooden
chair in the bathroom
provides somewhere to
pile up towels and put
down dishes of soap.
This particular soap dish
is appropriately carved
from soapstone.

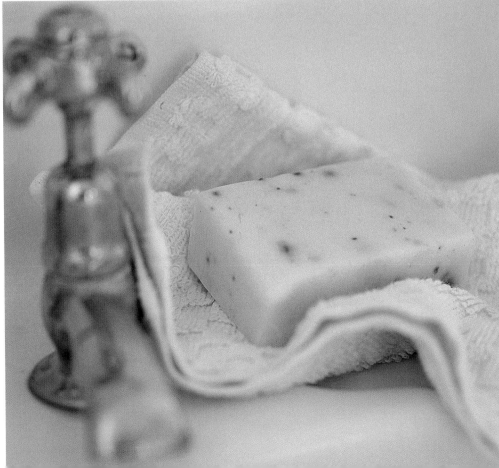

left Face cloths and hand
towels woven in a lovely
creamy slub add subtle
layers of colour here. I love
handmade soaps: they
smell like a fruit bowl and
look good enough to eat.

156 shades of white

1 Lido

2 Water Meadow

3 Aqua Mist

4 Nest Egg

5 Wattle II

6 Leamington Mist

summer

7 Cloud White

8 Cornflower White

9 Jade White

10 Chinoiserie

11 Gustave

12 Ice Blue

autumn

13 Celariac

14 Popcorn

15 Bamboo

16 Clotted Cream

17 Barley White

18 Buttermilk

winter

19 Linen

20 Sand III

21 Limestone

22 Shell

23 Stone II

24 Slate III

see overleaf for suppliers details

sources &
suppliers

shades of white suppliers from pp 156–7:
shades 1, 4, 11, 13, 14, 15, 19: Nina
Campbell @ Paint Library; 2, 3, 9, 17, 18:
Dulux; 5, 20, 23, 24: David Oliver – Paint
Library; 10, Crown Paints; 6, Homebase
Historic Tones; 12, Paint Magic; 16, 21, 22:
Kelly Hoppen "Perfect Neutrals" range.
(See below for full address details.)

united states

Colefax & Fowler
979 Third Avenue, New York
NY 10022
212.753.4488

Rose Cumming
The Fine Arts Building,
232 East 59th Street, New York
NY 10022
212.758.0844

Osborne & Little
90 Commerce Road, Stamford
CT 06902
203.359.1500

Restoration Hardware, Inc.
15 Koch Rd., Suite J
Corte Madera, CA 94925-1240
415.924.1005
*Various other locations throughout
the U.S.*

Smith & Hawken
East Coast:
696 White Plains Rd.
Scarsdale, NY 10583
914.722.0690

West Coast:
2040 Fillmore Street
San Francisco, CA 94115
415.776.3424
Various other locations throughout the U.S.

Crate & Barrel
East Coast:
777 Boylston, Boston, MA 02116
617.262.8100

650 Madison Ave.,
New York, NY 10022
212.308.0011

Midwest:
646 N. Michigan Ave.
Chicago, IL 60611
312.787.5900
Various other locations throughout the U.S.

IKEA
Washington, D.C. Area:
Potomac Mills Mall
2700 Potomac Circle, Ste. 888
Woodbridge, VA 22192
703.494.4532

East Coast:
1100 Broadway Mall
Hicksville, NY 11801
516.681.4532

West Coast:
Media City Center
600 N. San Fernando Blvd.
Burbank, CA 91502
818.842.4532
*Various other locations throughout
the U.S.*

Pier 1 Imports
East Coast:
461 5th Ave.
New York, NY 10017

West Coast:
3535 Geary Blvd.
San Francisco, CA 94118
*Various other locations throughout
the U.S.*

Portico Bed & Bath
903 Broadway
New York, NY 10010
212.328.4343

Gracious Home
1220 3rd Ave.
New York, NY 10021
212.517.6300

Waterworks
237 E. 58th St.
New York, NY 10022

united kingdom

antiques

Guinevere Antiques
578 Kings Road,
London SW6 2DY
020 7736 2917

china, glass and tableware

Antony Stern
Avro House, Havelock Terrace,
London W8
020 7622 9463

flowers and plants

John Carter
Studio C3, The Depot, 2 Michael Road,
London SW6 2AD
020 7731 5146

Grovers Ltd
7–9 Exhibition Road, London SW7 2HE
020 7584 5090

specialty shops

Nina Campbell
9 Walton Street, London SW3 2JD
020 7225 1011 *and*
7 Milner Street, London SW3
020 7589 8589

Kelly Hoppen Interiors
Alma Studios, Stratford Road,
London W8
020 7938 4151

Louise Bradley
15 Walton Street, London SW3 2HX
020 7589 1442

Stephanie Hoppen
17 Walton Street, London SW3 2HX
020 7589 3678

Chelsea Textiles
7 Walton Street, London SW3 2JD
020 7584 0111

Baker & Spice
46 Walton Street, London SW3 1RB
020 7589 4734

Monogrammed Linen Shop
168 Walton Street, London SW3 2JL
020 7589 4033

de Le Cuona
1 Trinity Place, Windsor,
Berkshire SL4 3AP
01753 830301

General Trading Company
144 Sloane Street, London SW1X 5BL
020 7730 0411

Wendy Cushing
G7 Chelsea Harbour Design Centre,
London SW10 0XE
020 7351 5796

bedlinen, tablelinen, furniture
and soft furnishings

Andrew Martin
200 Walton Street, London SW3 2JL
Telephone: 020 7584 4290

The White House
102 Waterford Road, London SW6 2HA
020 7629 3521

Heals
196 Tottenham Court Road,
London W1P 9LD
020 7636 1666

accessories

Divertimenti
139 Fulham Road, London SW3 6SD
Telephone: 020 7581 8065

David Mellor
4 Sloane Square, London SW1W 8EE
020 7730 4259

Muji
26 Great Marlborough Street,
London W1V 1HL
020 7494 1197

The Holding Company
184 New Kings Road, London SW6 4NF
020 7610 9160

paint suppliers

Crown Paints (available nationwide)
020 8533 3513

Dulux (available nationwide)
01753 550000

Fired Earth
Twyford Mill, Oxford Road
Adderbury, Oxon OX17 3HP
01295 812088
For Kelly Hoppen's "Perfect Neutrals"

Homebase (stores nationwide)
020 8784 7200

Paint Library
3 Elystan Street, London SW3 3NT
020 7823 7755

Paint Magic
79 Shepperton Road, London N1
020 8960 9960

index &
acknowledgements

Acknowledgements

Louise Bradley for allowing us to photograph her delicious apartment. Nina Campbell and her daughter, Rita Konig, for laying tables for me to shoot – their rooms have appeared in all my books since day one. Genevieve Weaver and her sons and daughters-in-law who allowed me to photograph profusions of white and cream things in Guinevere, their Aladdin's cave. A huge thank you to Rob who styled the Guinevere shoots with talent, a great eye and endless patience. Again – I would feel lost without their constant co-operation. Bernie de Le Cuona for her generosity in lending us both her home and her beige and cream accessories. Anne Singer from the Monogrammed Linen Shop. Mona Perlhagen of Chelsea Textiles. Stuart Hands for his advice and help (The Curtain King!).Rob Honey and Dave Lawrence at Grovers for great flowers.Gail Stephens of Baker & Spice who opened her home when the light suddenly turned bad and we could not photograph her wonderful shop. Andrew Wood my photographer who, from day one, knew what I wanted even before I did and who made all the long days of photography a delight. And, above all, my editor and friend, Cindy Richards – who has faith in my instincts and who knows how to coerce me into whatever she wants from me.